3—

STATES OF DECAY

STATES OF DECAY

By Daniel Barter & Daniel Marbaix

A catalogue record for this book is available from the British Library.

First published in Great Britain in 2013 by Carpet Bombing Culture.

email: books@carpetbombingculture.co.uk
© Carpet Bombing Culture. Pro-actif Communications

ISBN: 978-1908211125

www.carpetbombingculture.co.uk

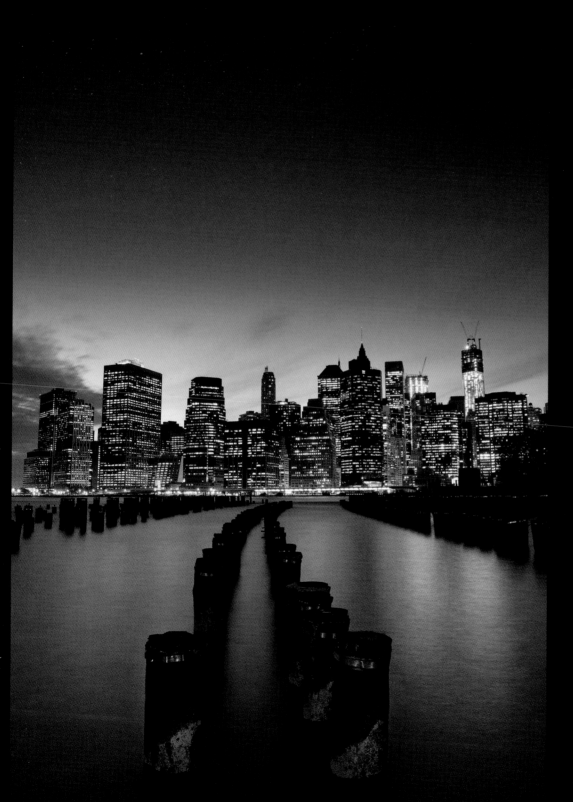

View at dusk
Manhattan, New York

INTRODUCTION

A new breed of urban adventurers take a savage ride through the hidden story of America's North East. Join us as we follow two explorers' journey through derelict spaces. From NYC to the infamous Rust Belt, once home to America's heavy industry, 'States of Decay' brings you a glimpse of the broken, the doomed, the entropic dreamlands on the flipside of the silver dollar coin. The morbid counterparts to the modern America that pumps greenbacks from its corporate epicentres through its far reaching veins, nurturing its glossy surfaces.

Peer into the recent past as dark histories unfold and their stories are told. Journey into atmospheric asylums, derelict houses of worship, forgotten educational institutions, industrial monoliths, vacant hotels, desolate transport hubs, and other ruins of the 20th century. See them as they stand today. Travel back in time and immerse yourself in the shadows of their past.

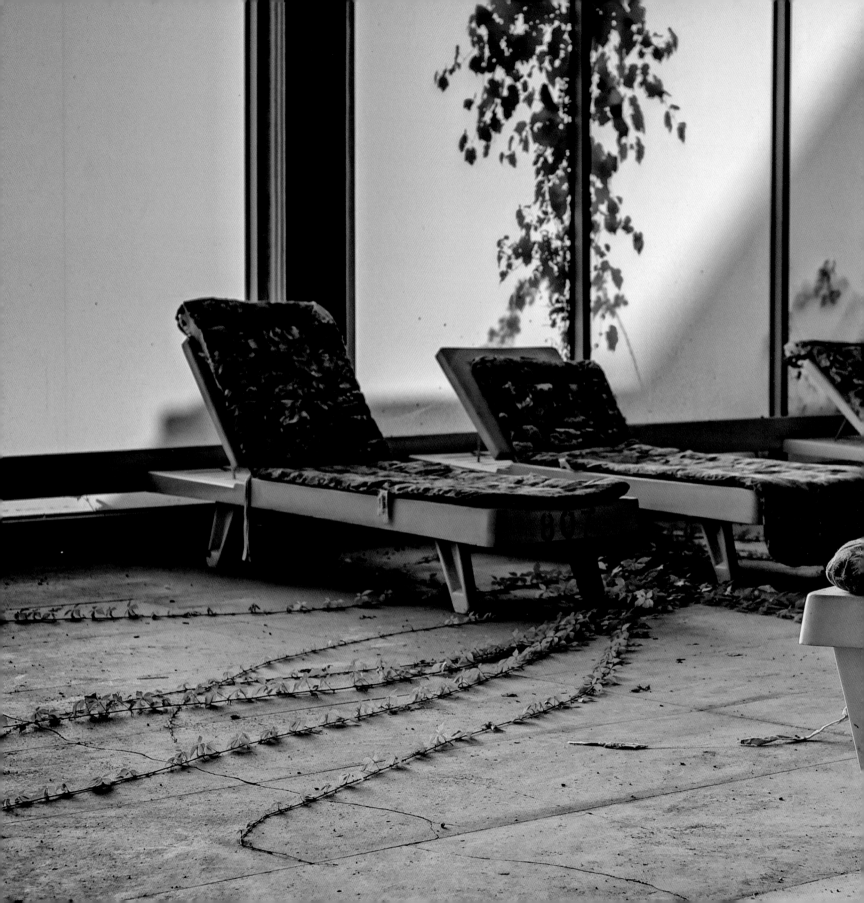

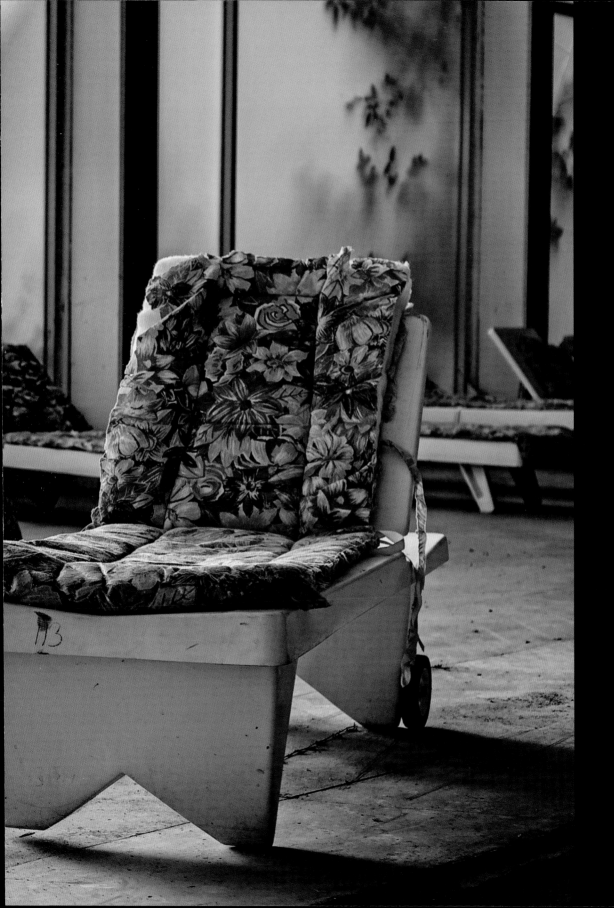

Resort, Ne

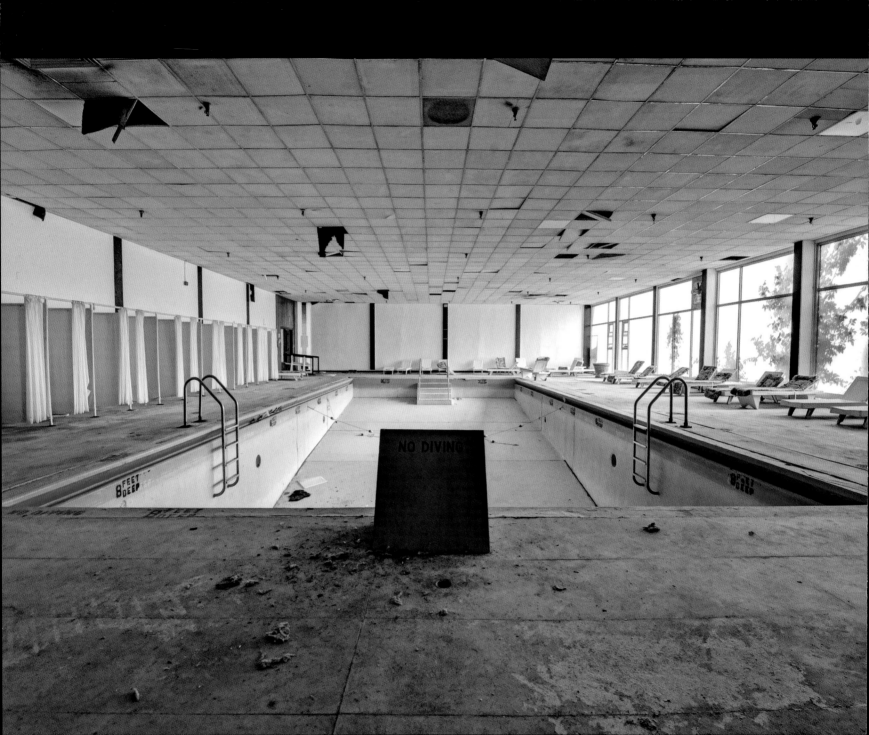

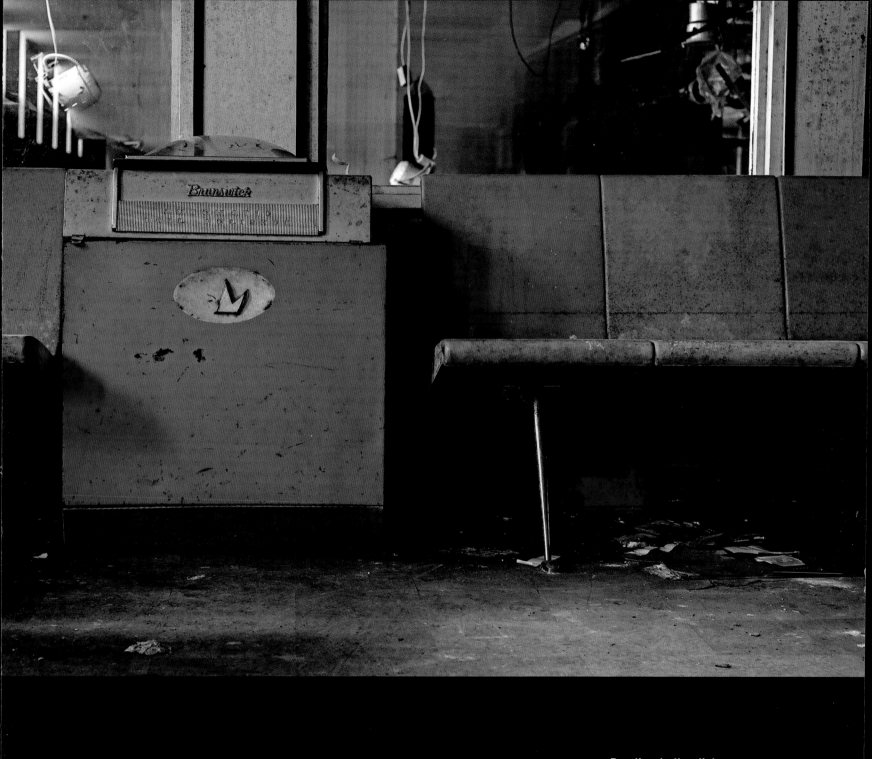

Bowling ball polisher
Resort, New York

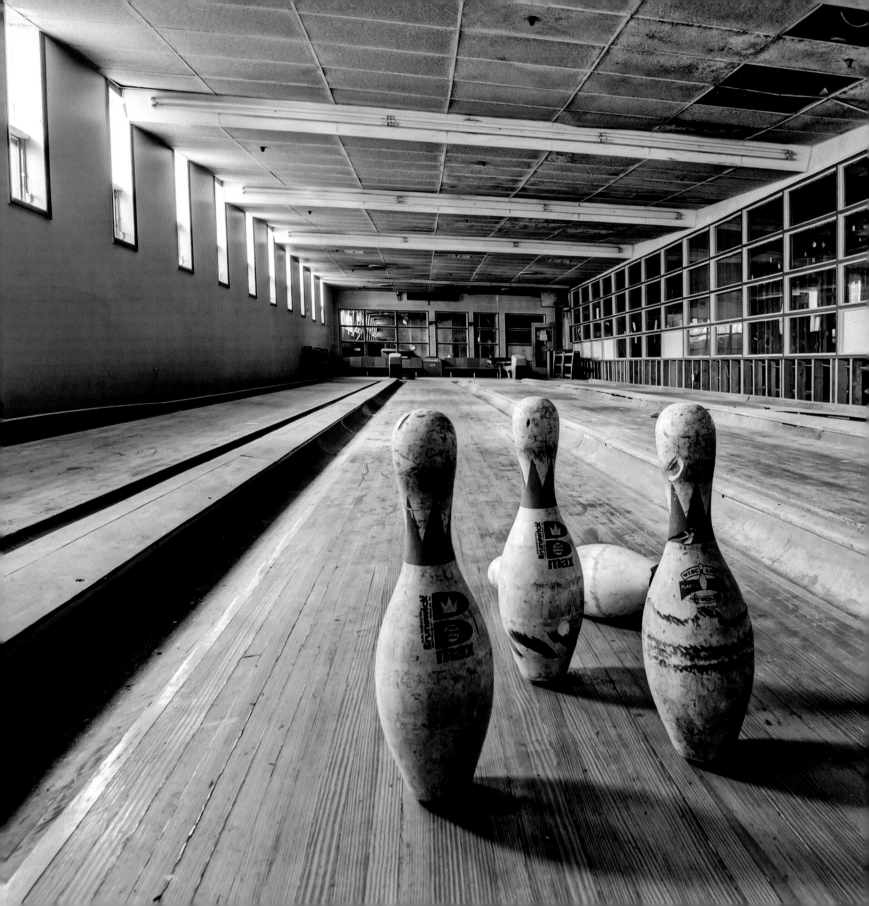

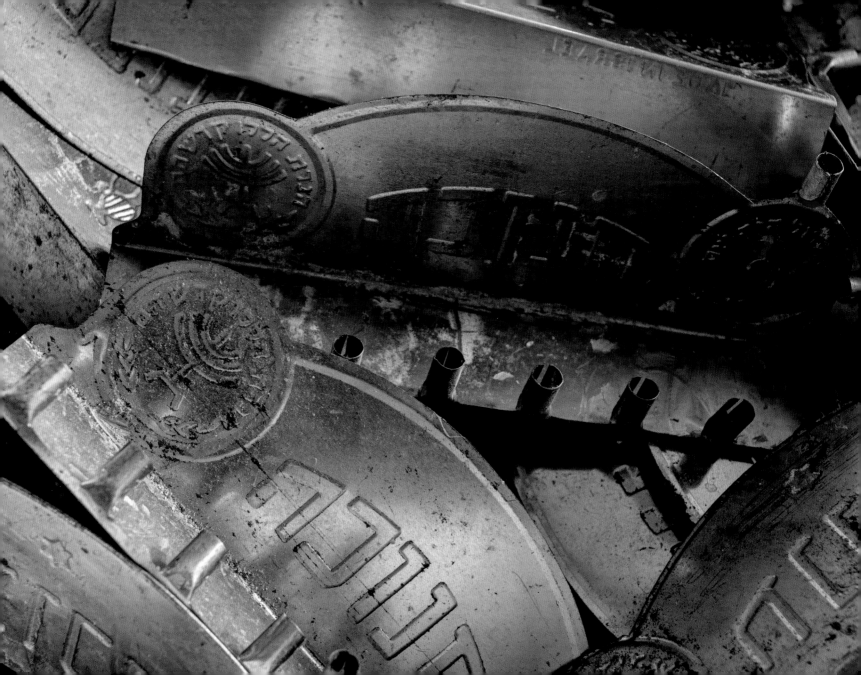

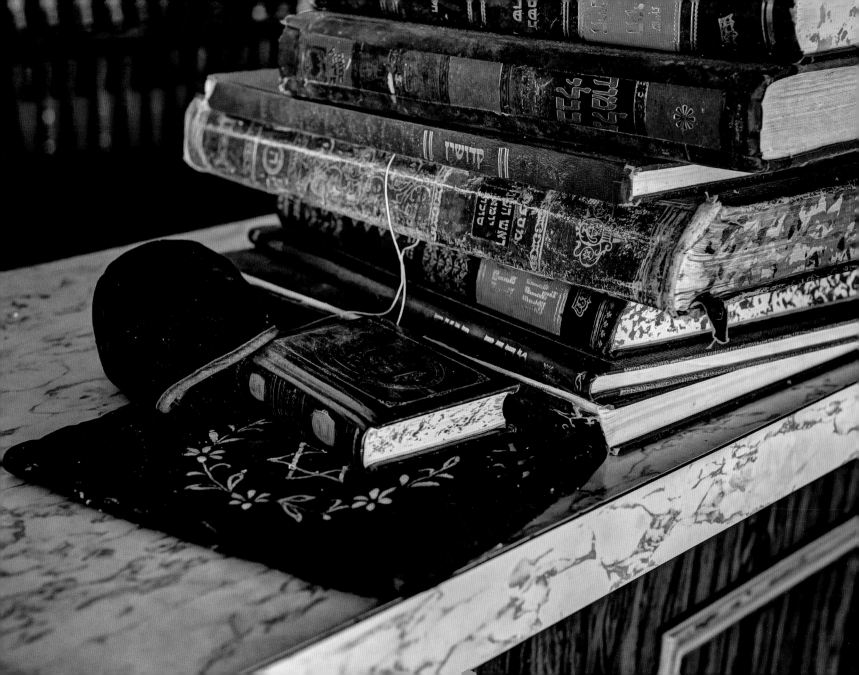

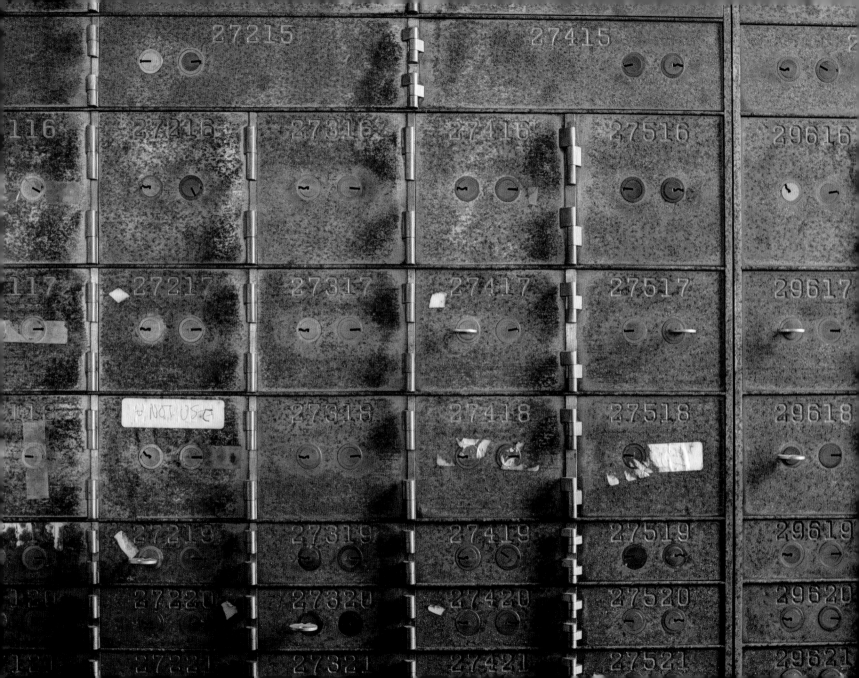

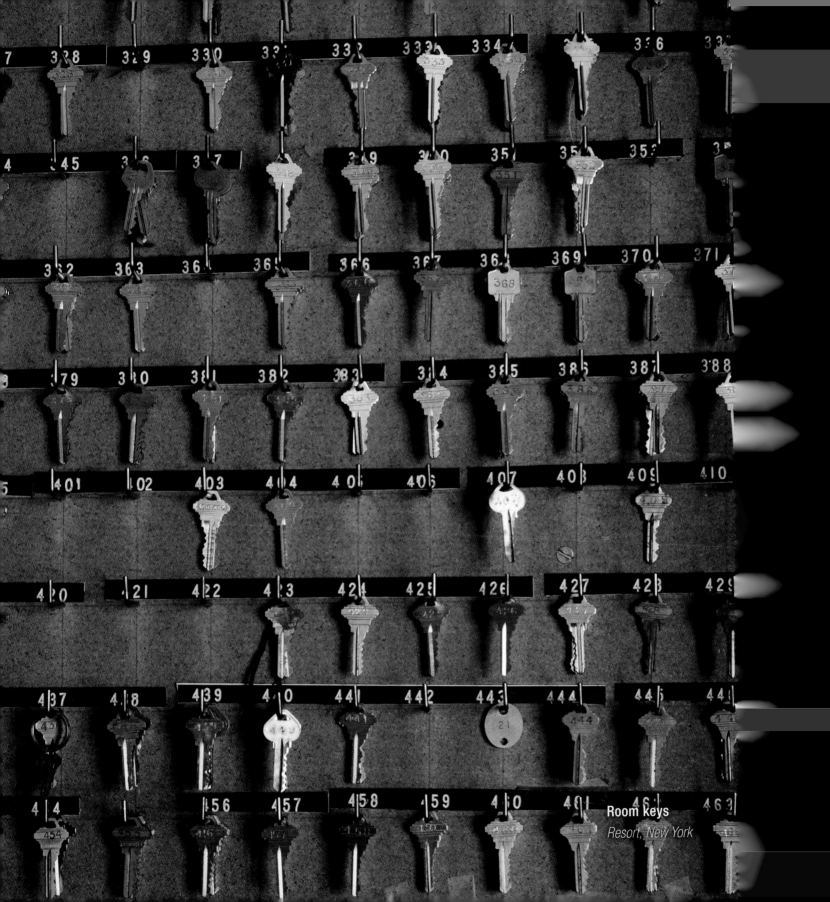

Room keys
Resort, New York

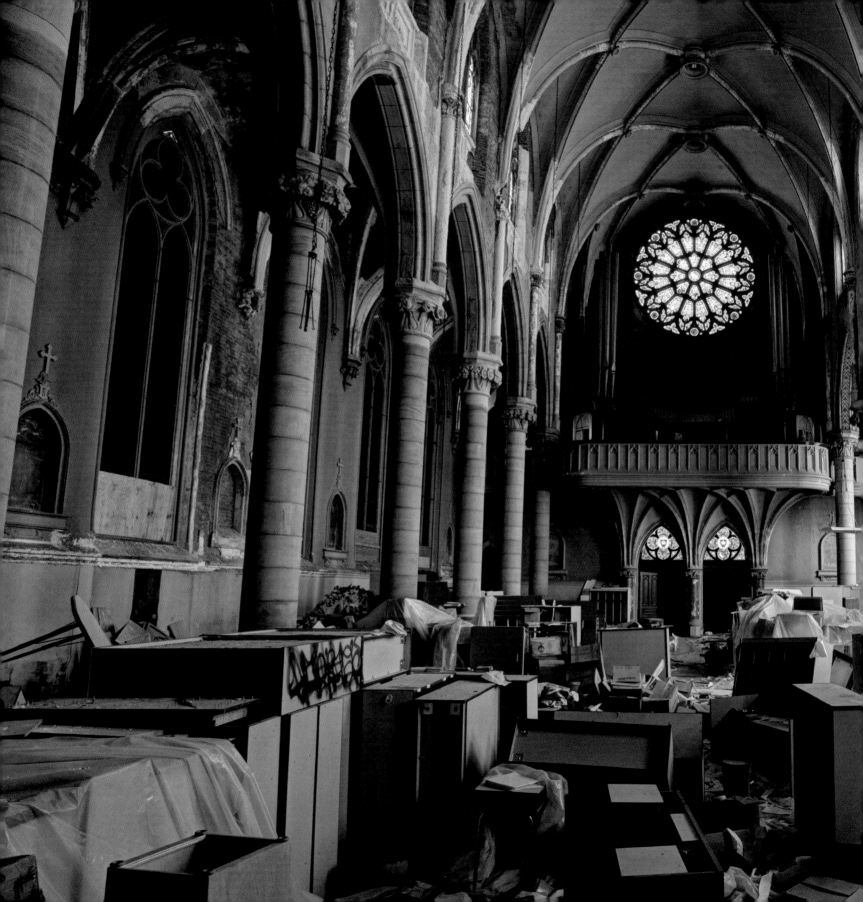

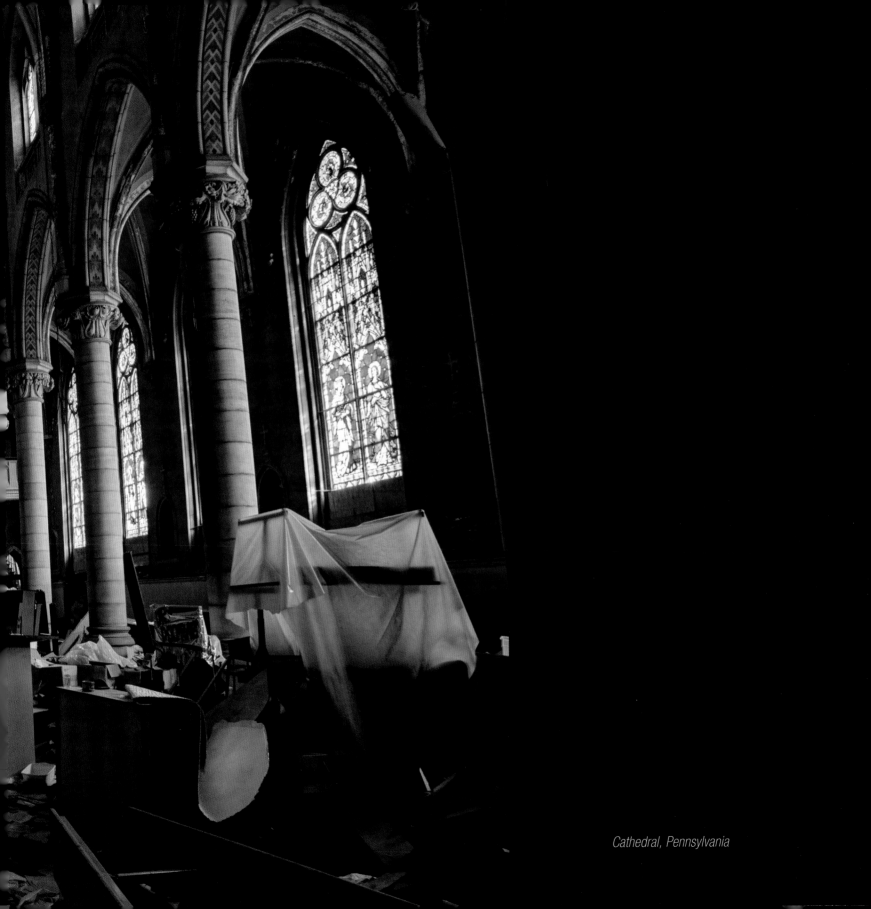

Cathedral, Pennsylvania

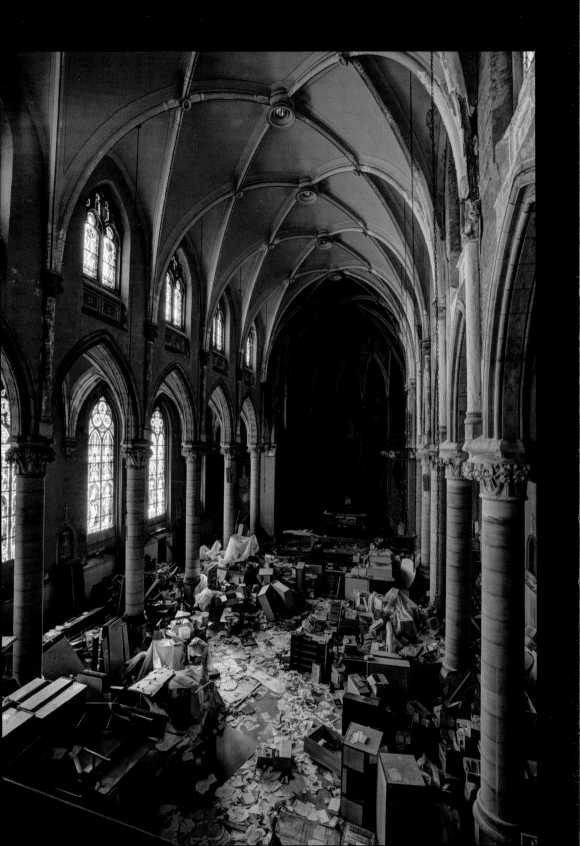

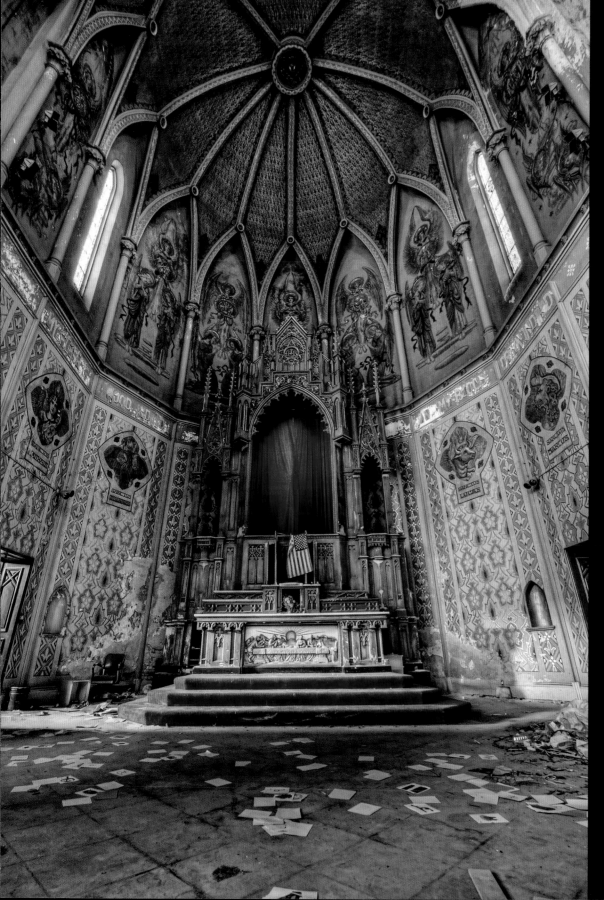

Cathedral, Pennsylvania

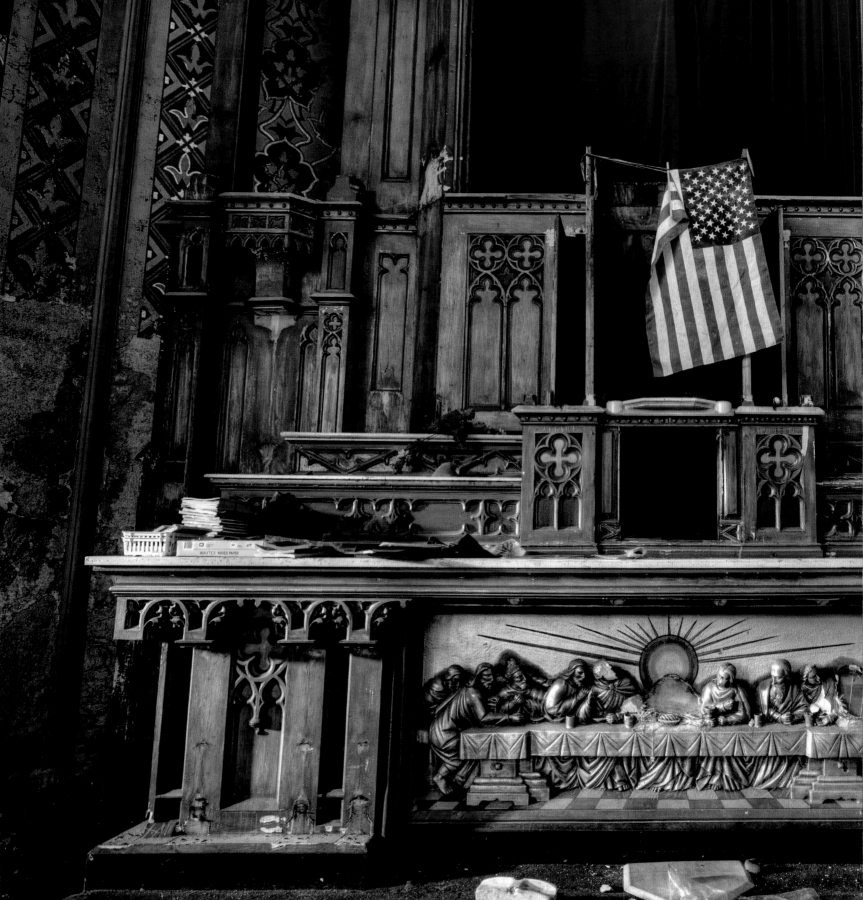

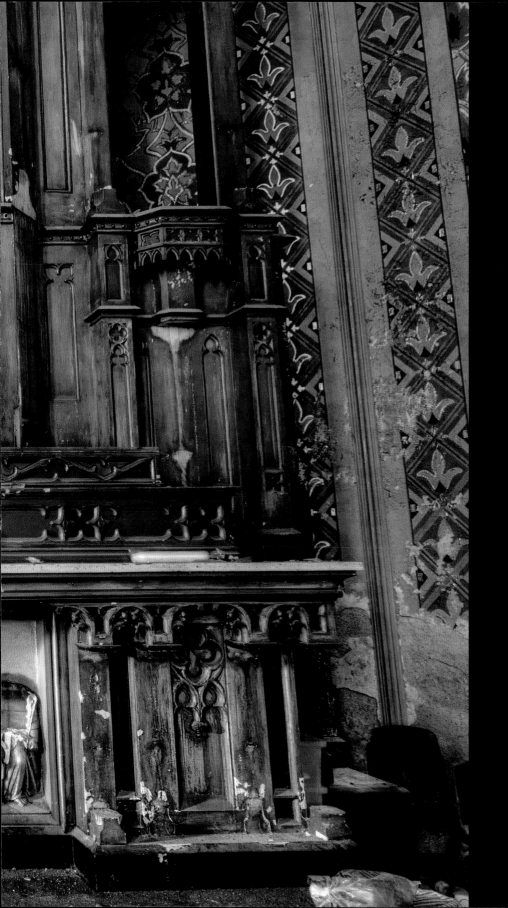

Cathedral, Pennsylva

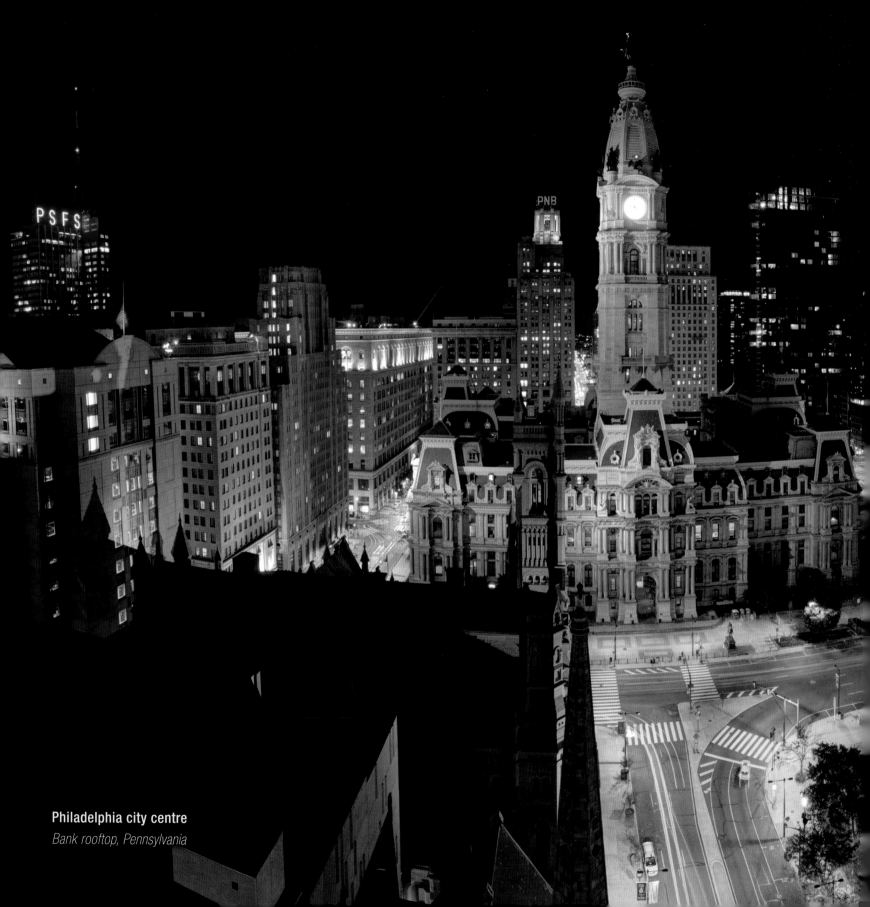

Philadelphia city centre
Bank rooftop, Pennsylvania

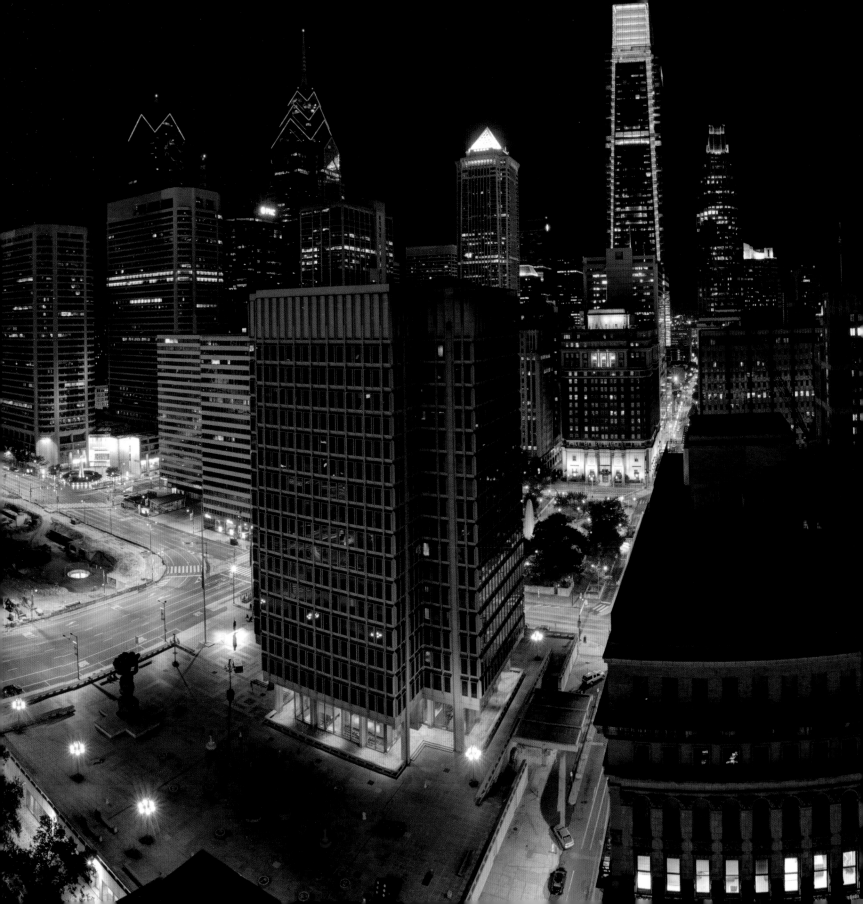

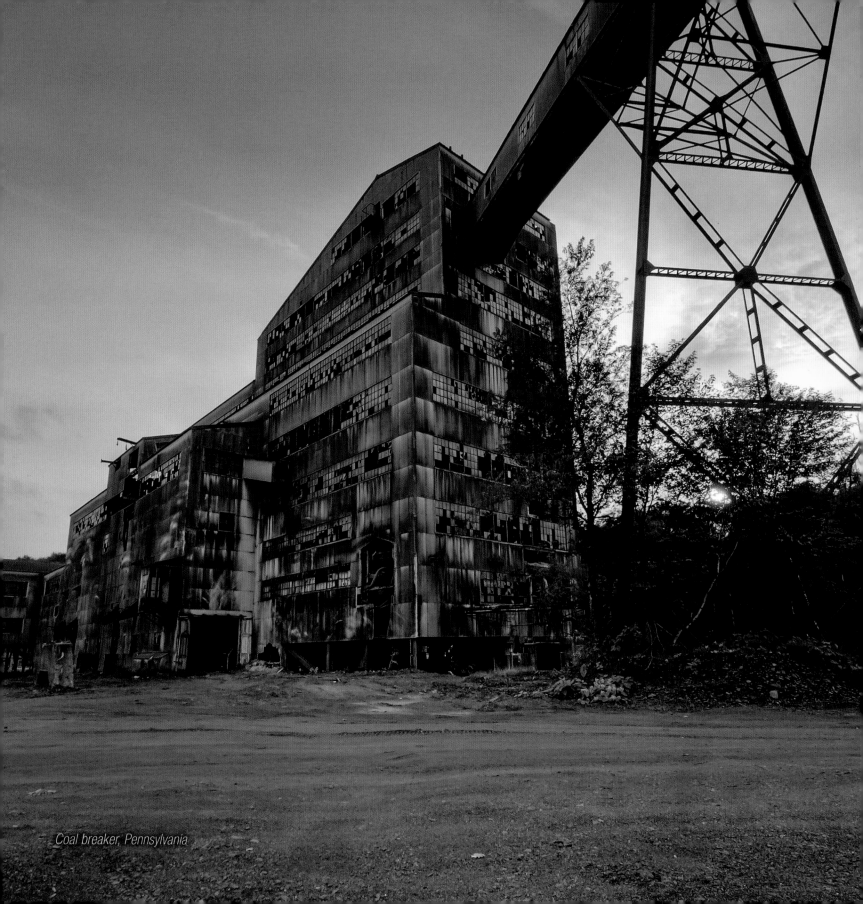

Coal breaker, Pennsylvania

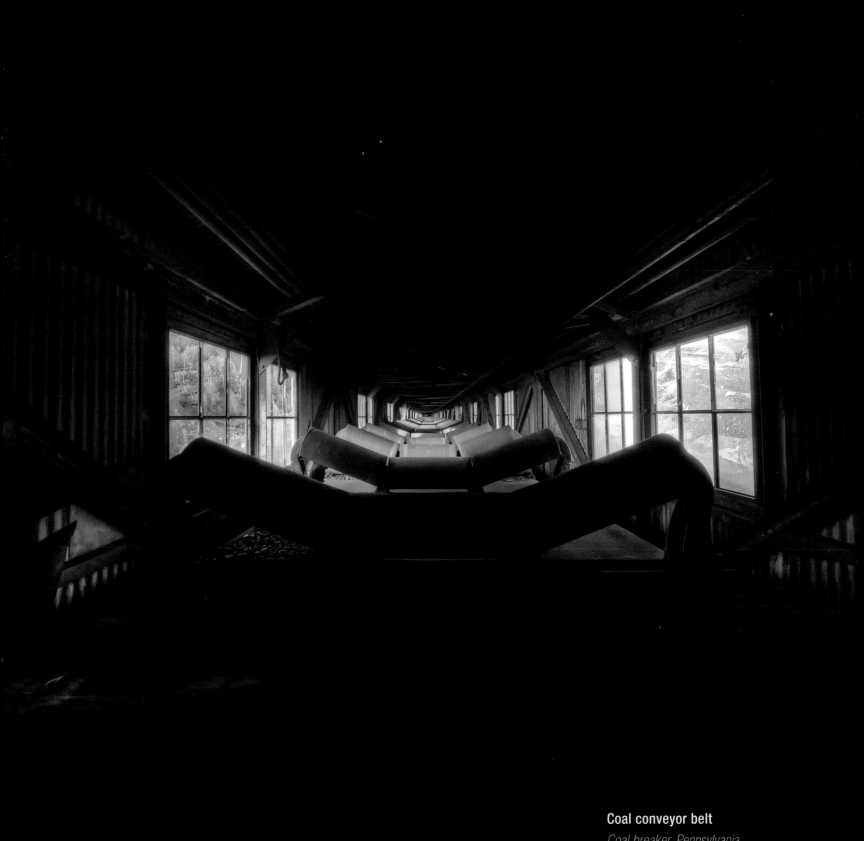

Coal conveyor belt
Coal breaker, Pennsylvania

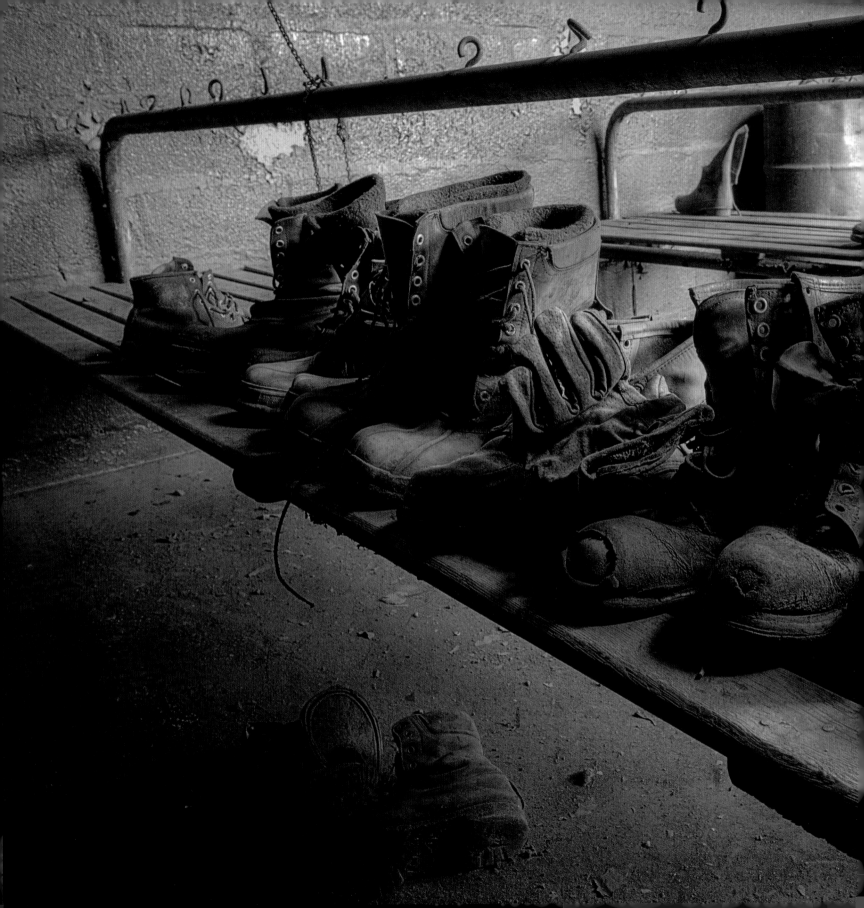

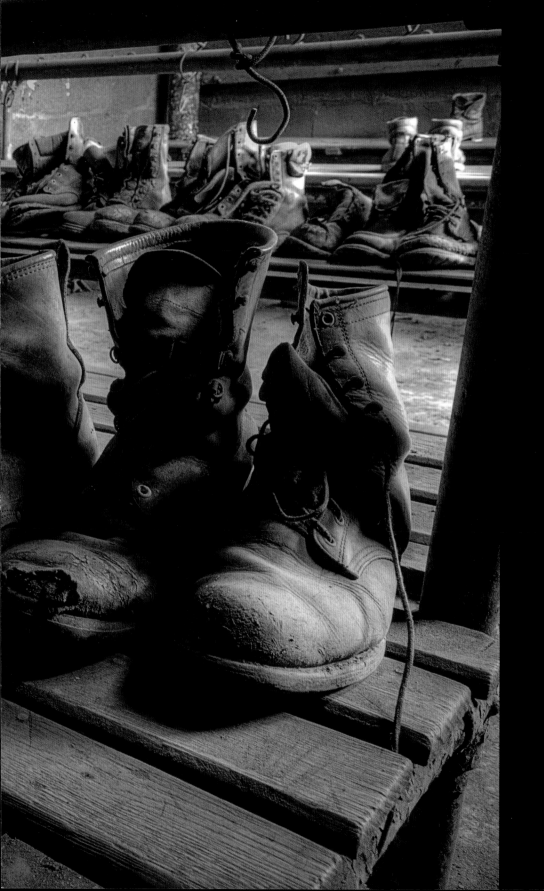

Coal breaker, Pennsylvania

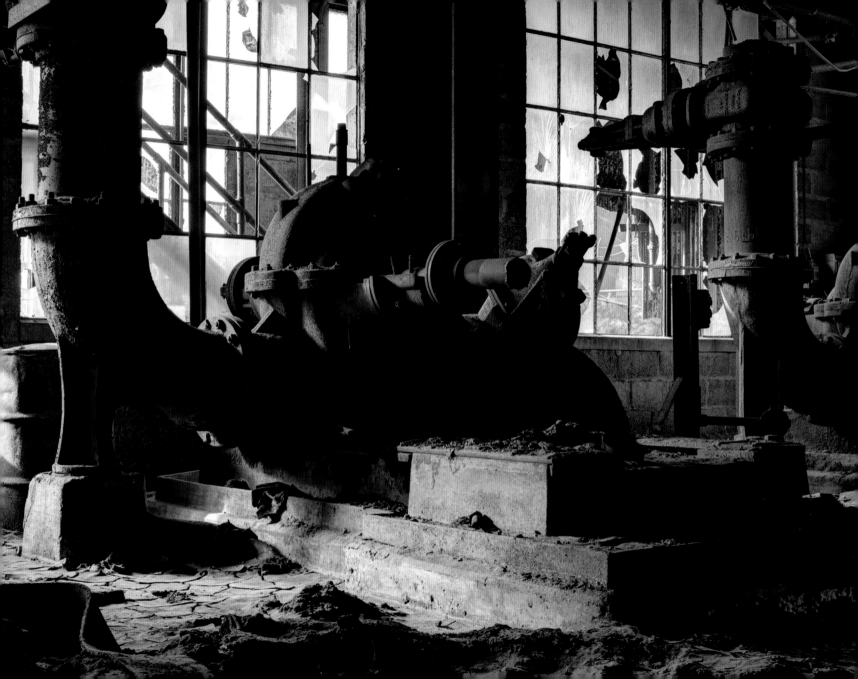

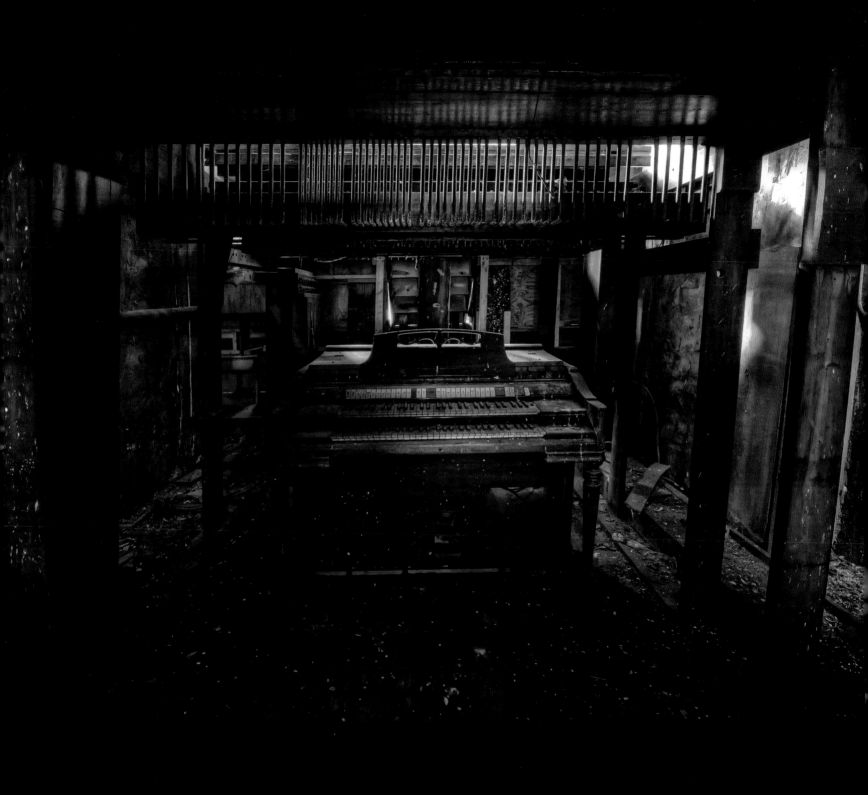

Church, Pennsylvania

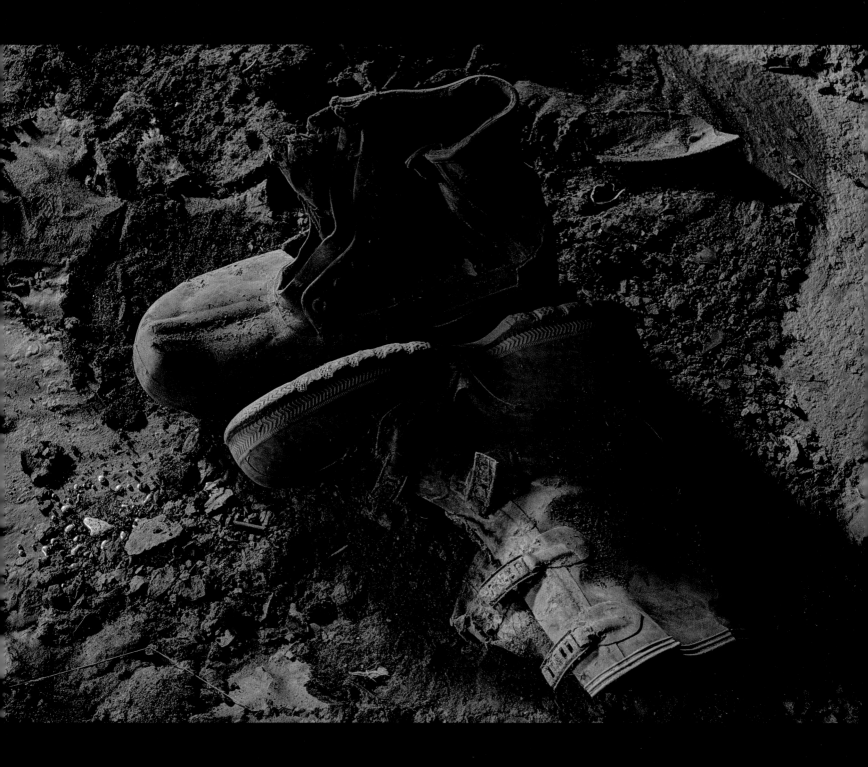

Worker's boots and mercury

Coal breaker, Pennsylvania

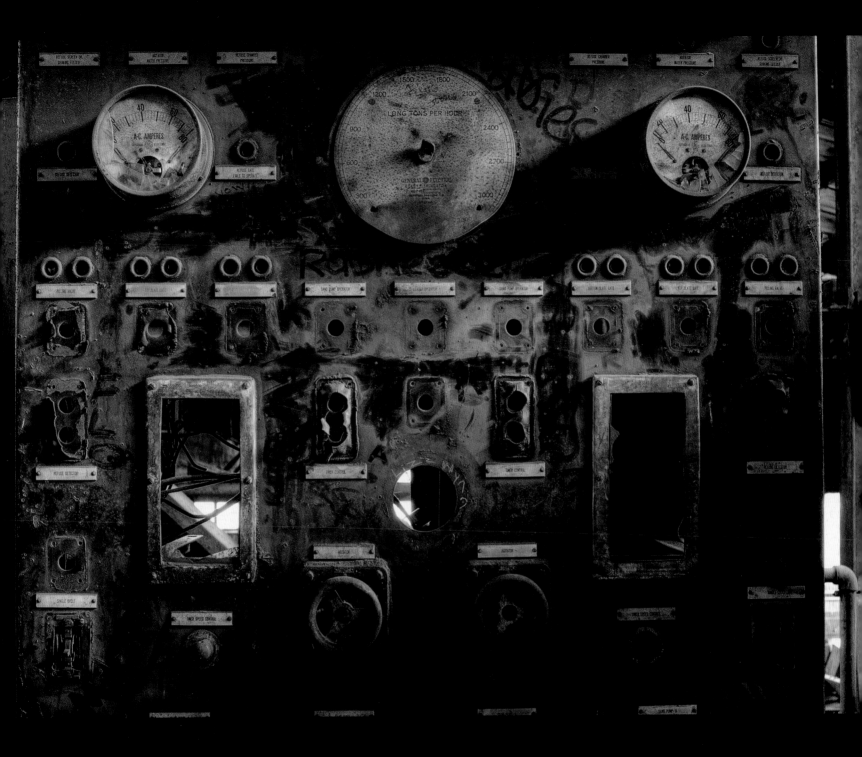

Coal breaker, Pennsylvania

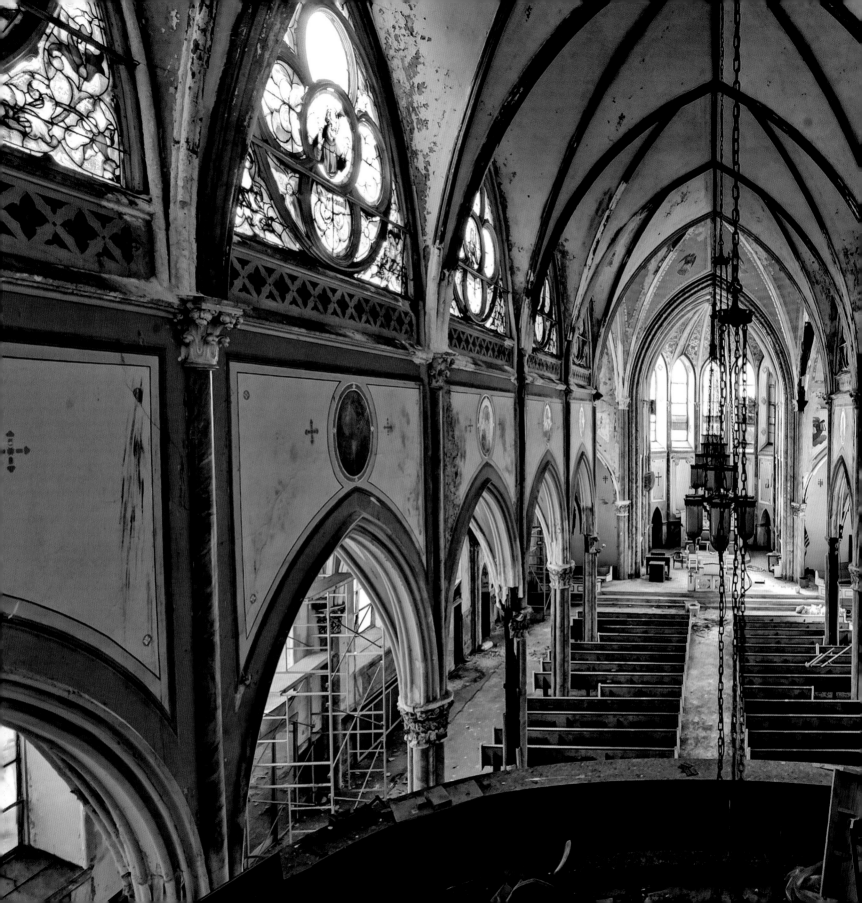

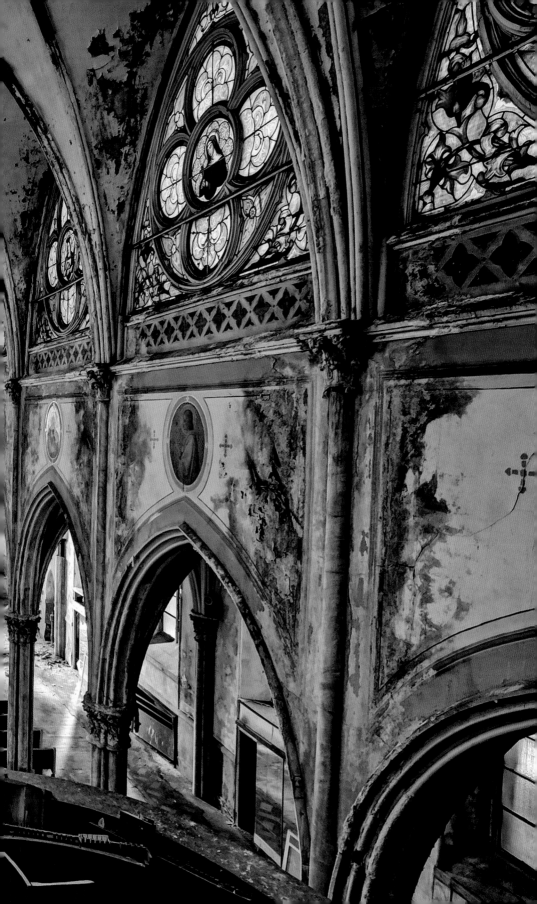

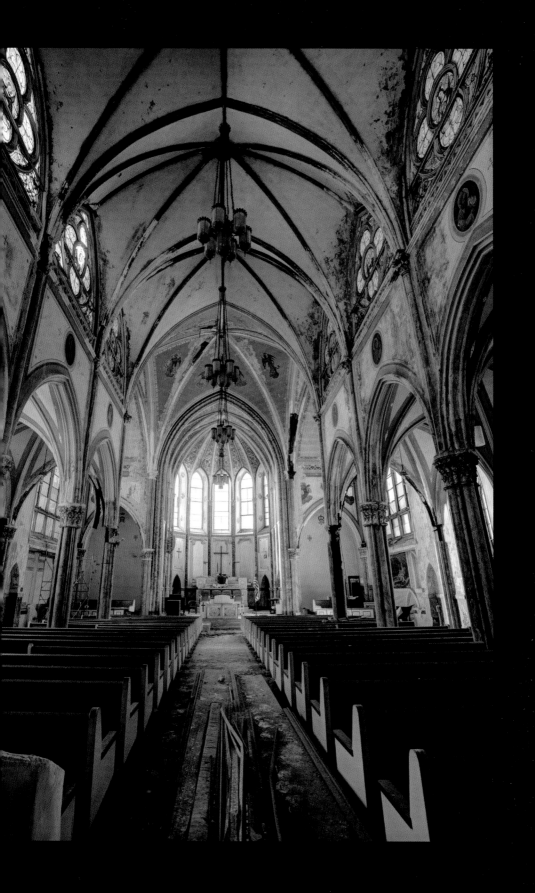

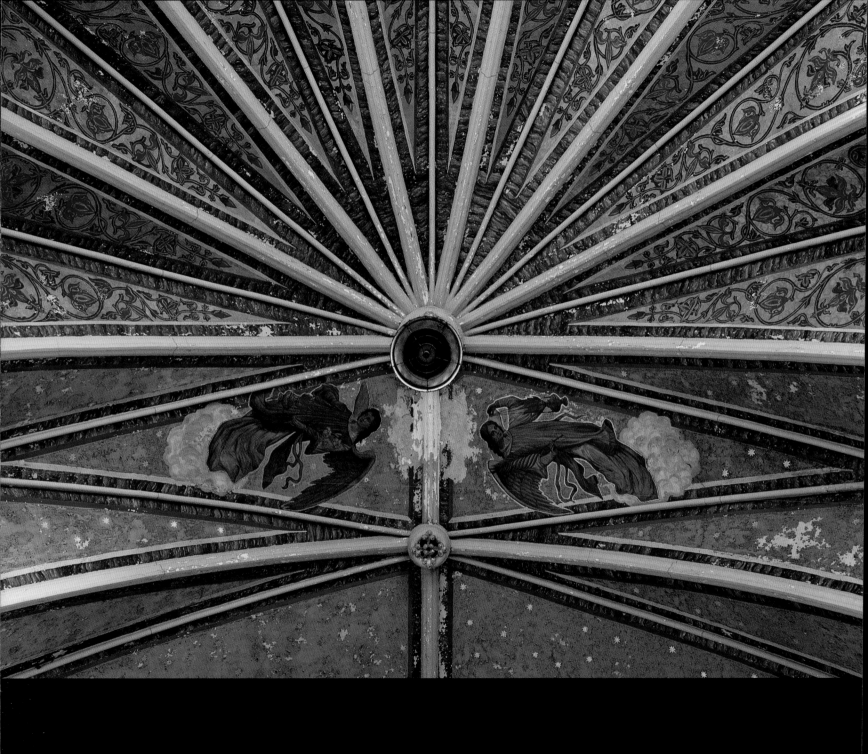

Ceiling detail
Church, Pennsylvania

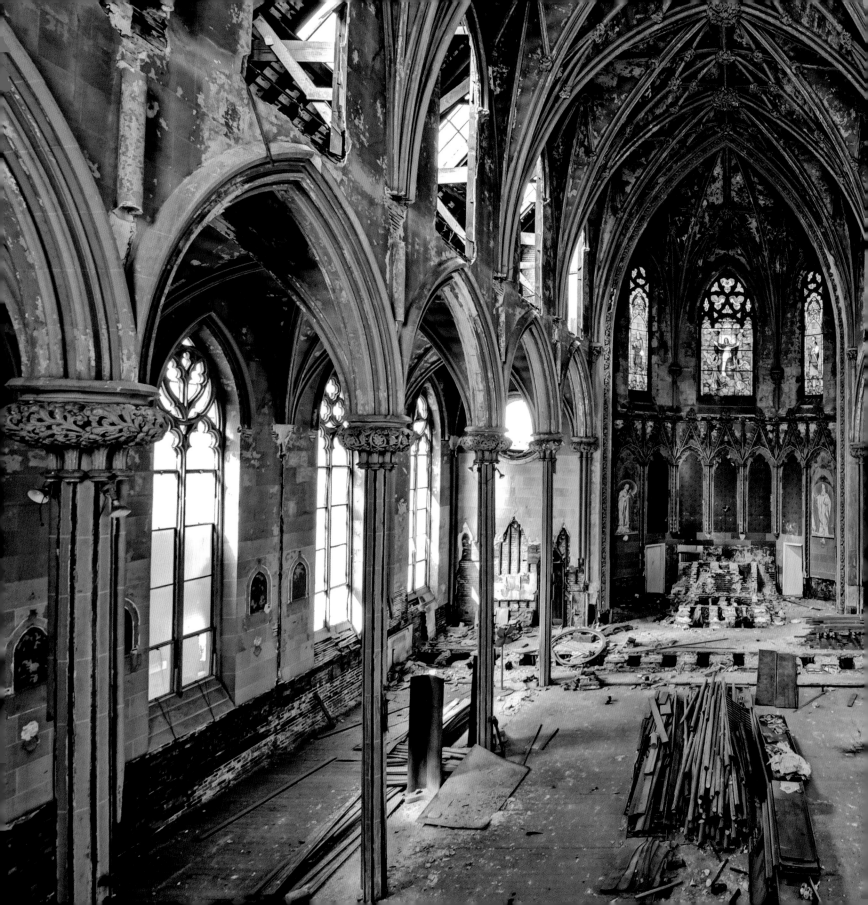

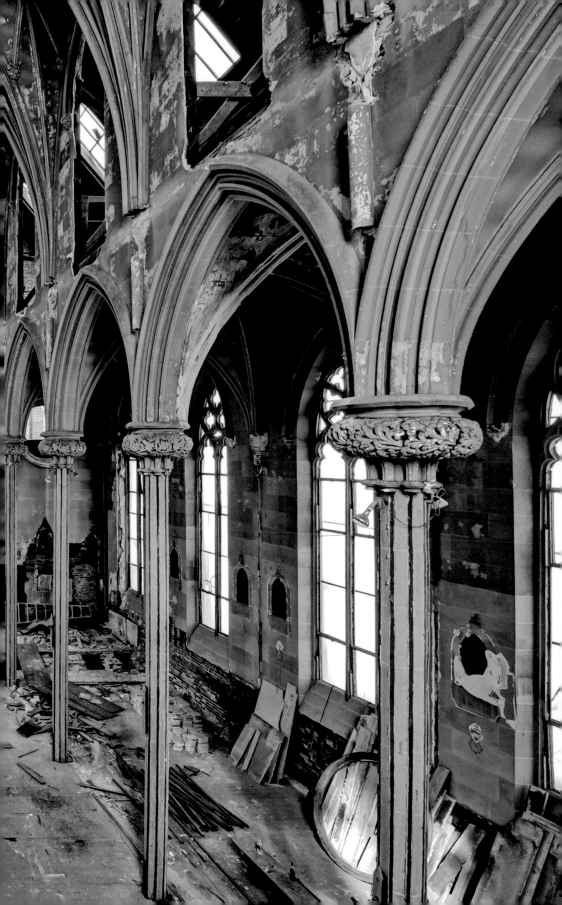

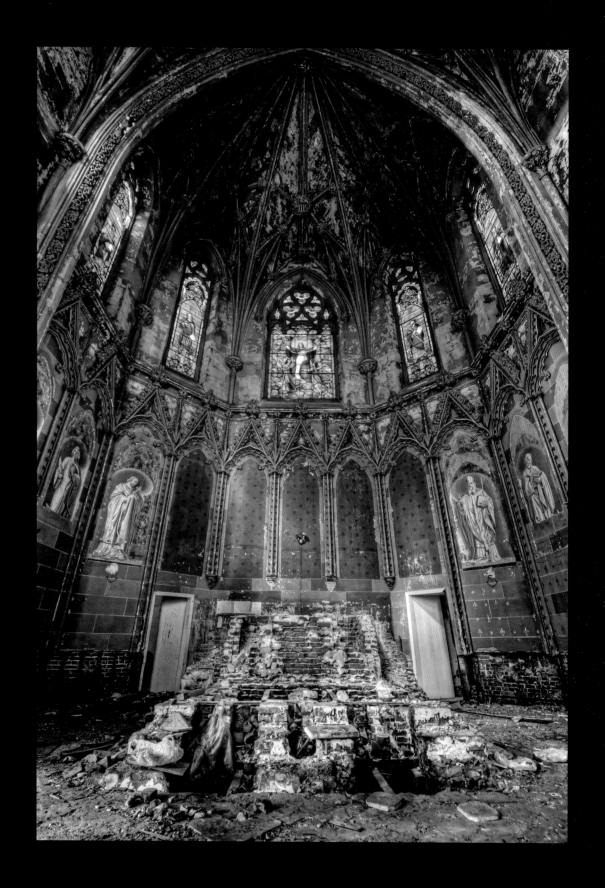

Church, Pennsylvania

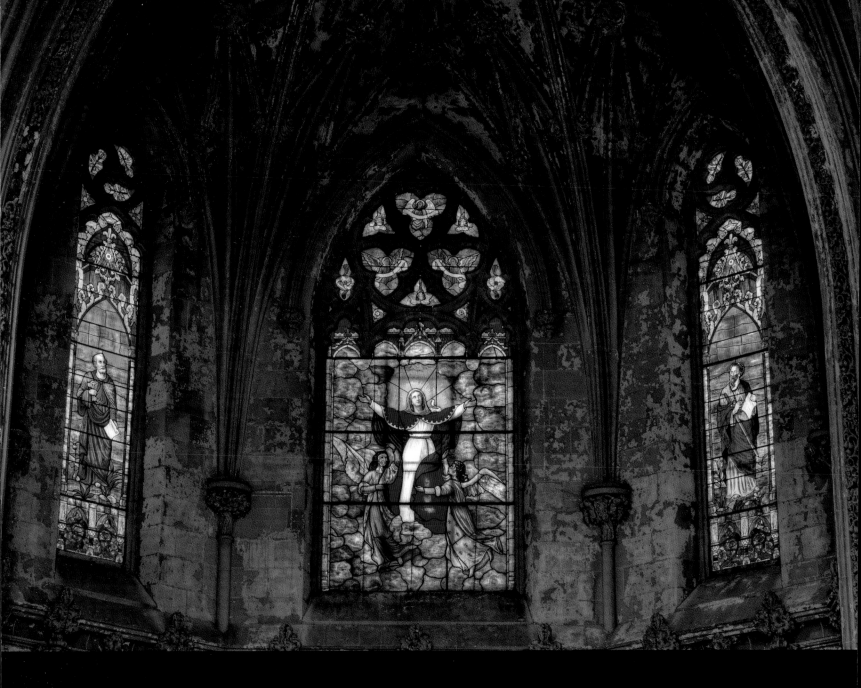

Church, Pennsylvania

URBAN EXPLORATION

The activity of urban exploration, which is often referred to as Urbex, can be summarised as the discovery and exploration of man-made structures and the rarely seen parts of the urban environment. It is primarily concerned with abandoned, neglected, and off-limits buildings and structures. Urban explorers are interested in a variety of different man-made structures. These spaces can be generally split into two separate categories: abandonments and active sites. The sites or places that urban explorers generally visit include asylums, schools, hospitals, factories, power plants, amusement parks, residences, military sites, mines, tunnels, train stations, railways, theatres, cranes, drains, missile silos, fallout shelters, sanatoriums, holiday camps, and rooftops.

Urban exploration can be considered a hobby, albeit an extreme one. It is fascinated with risk taking, at the fringes of the built environment. Explorers encounter various dangers or risks when they visit these forgotten spaces. These risks can include asbestos, hazardous materials, sagging floors, collapsed roofs, metal thieves, sharp objects, guard dogs, swarms of bugs, possible arrest, security guards, and drug syringes.

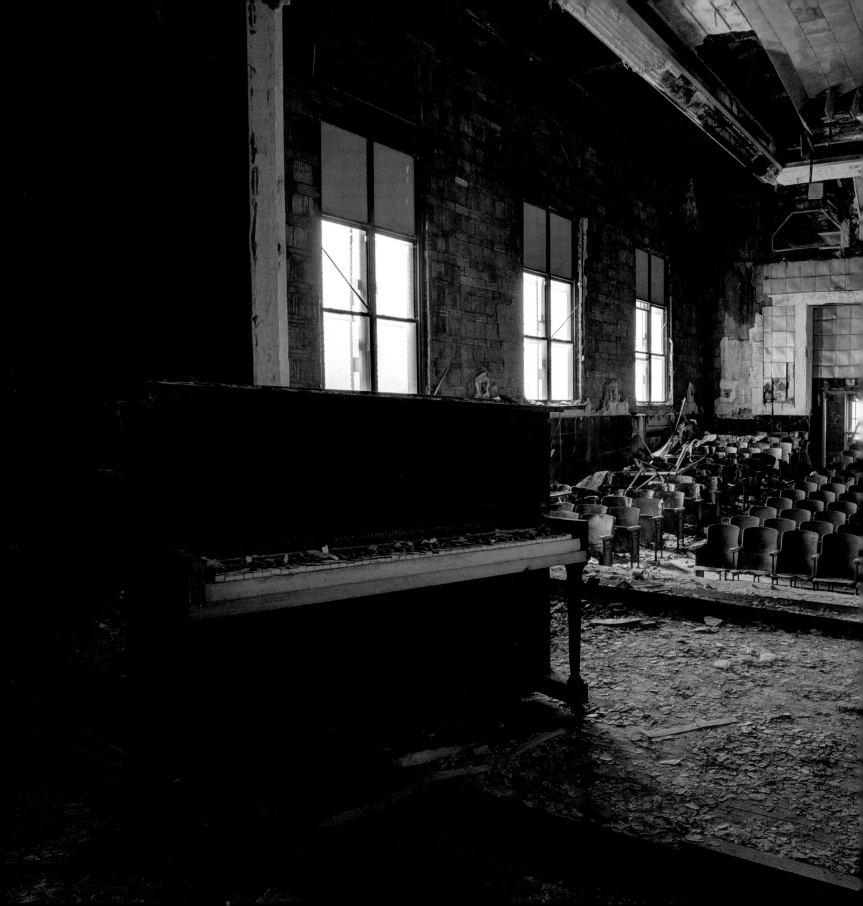

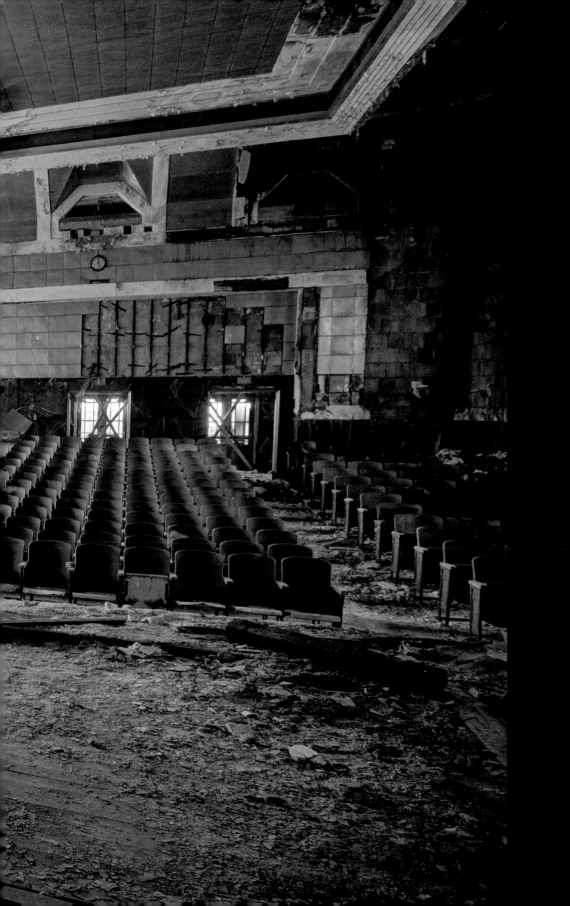

Elementary school, Pennsylvania

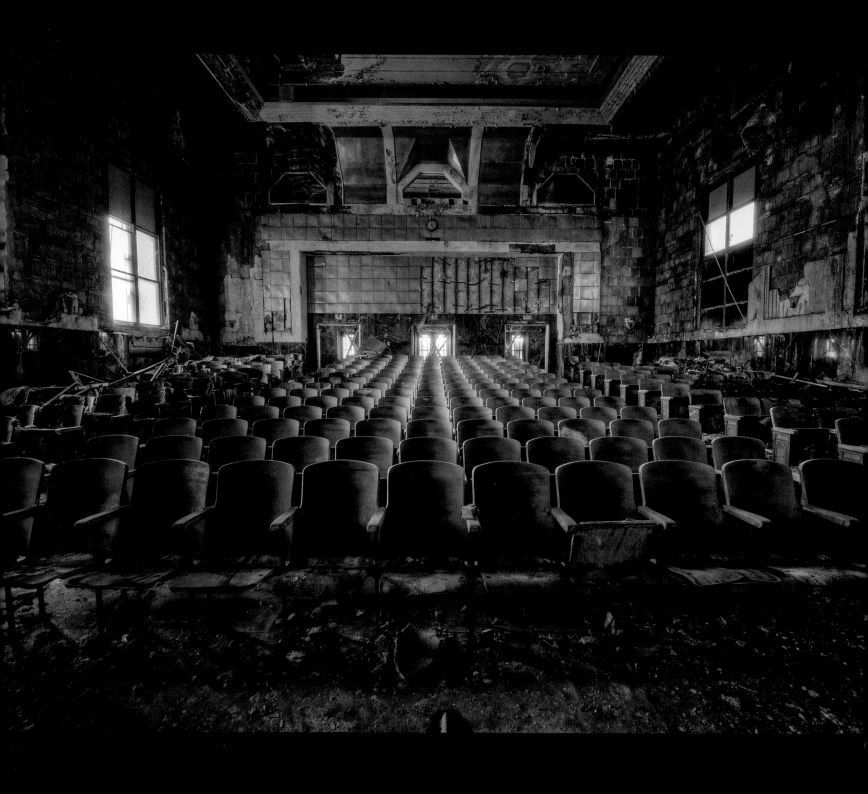

Elementary school, Pennsylvania

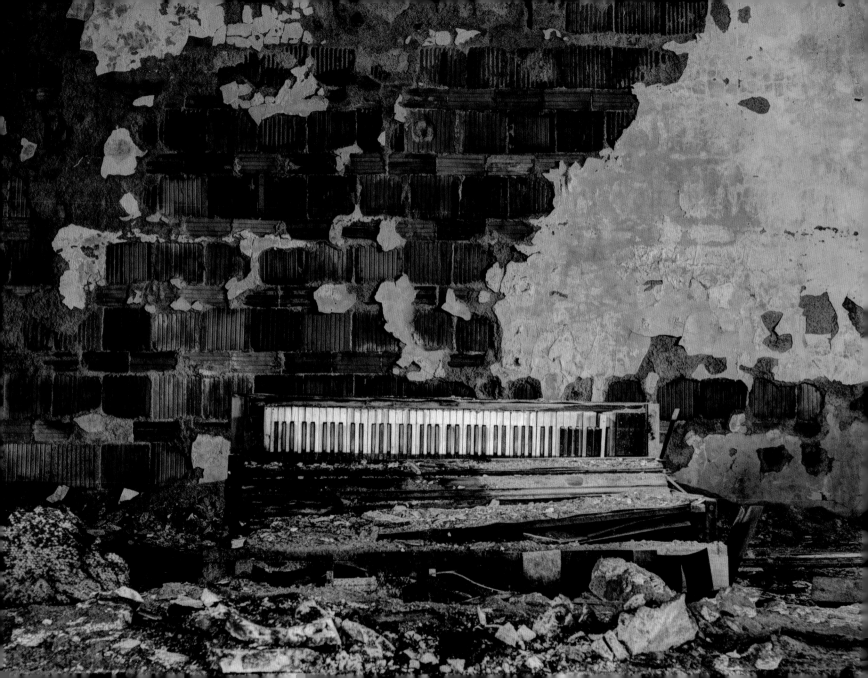

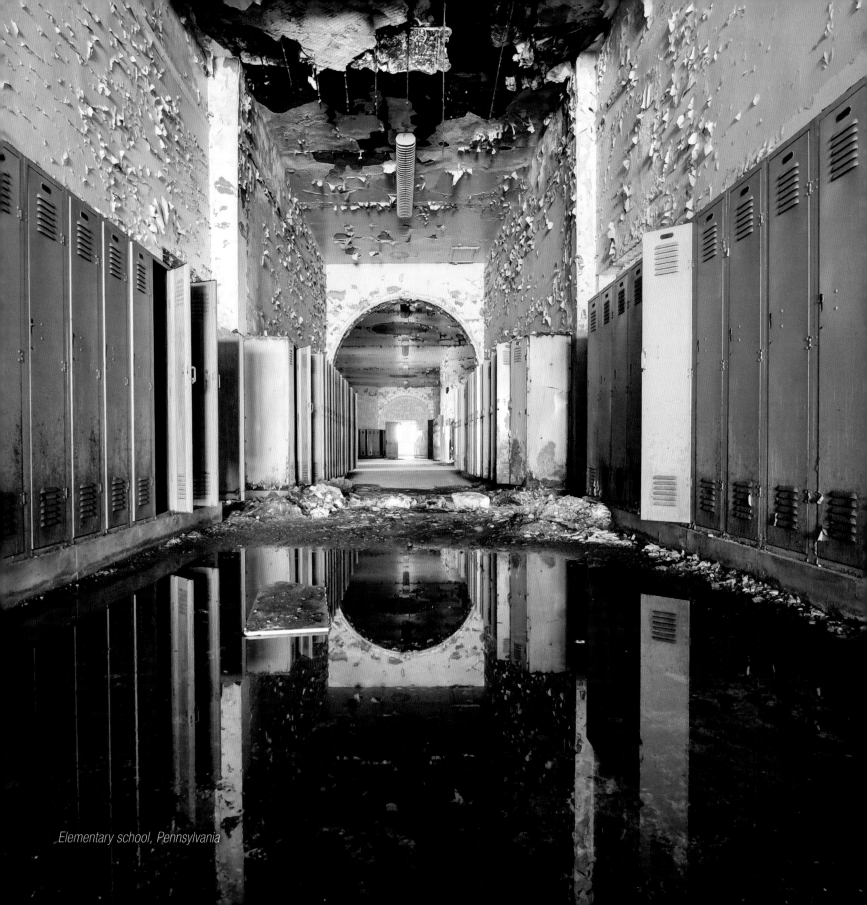

Elementary school, Pennsylvania

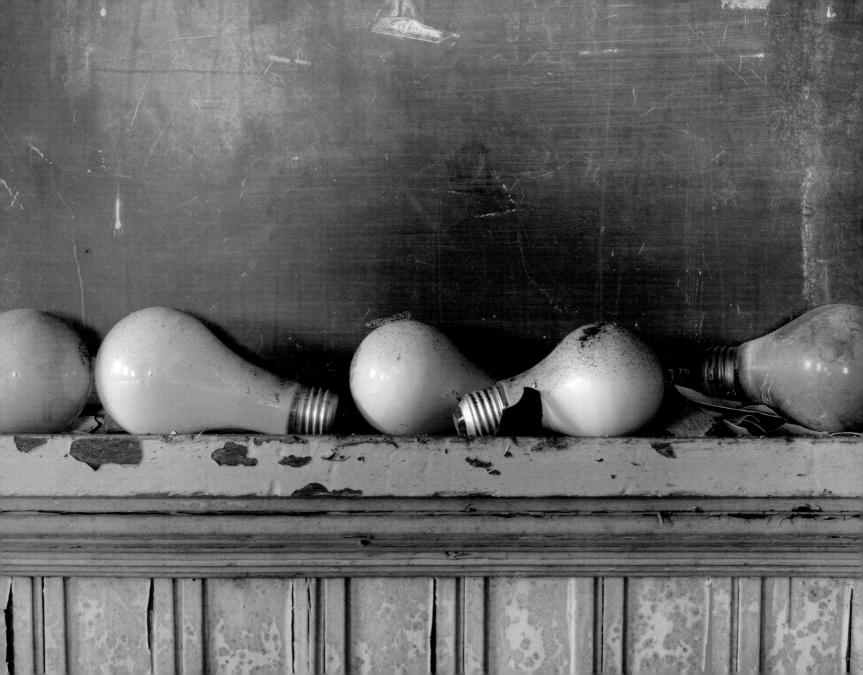

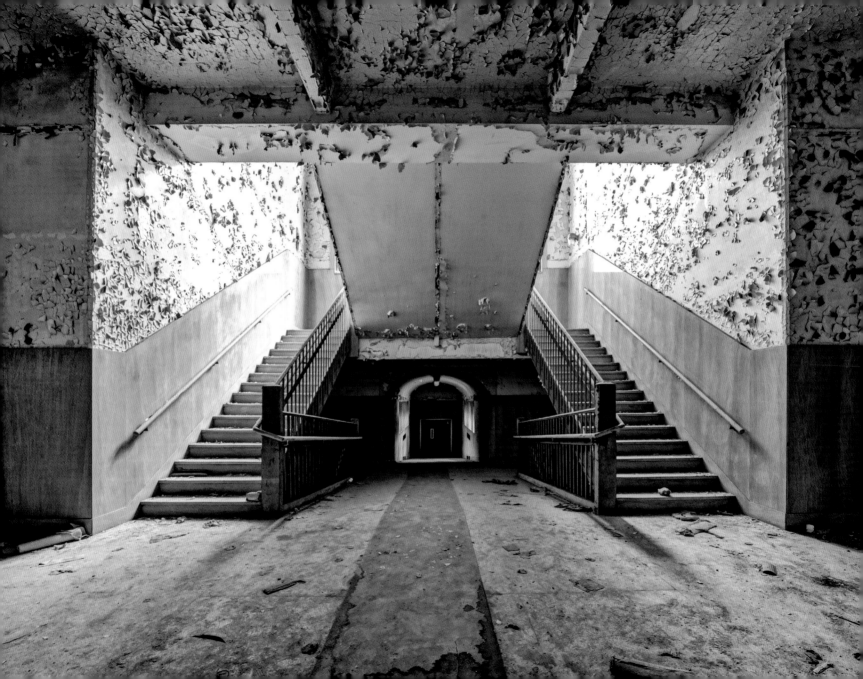

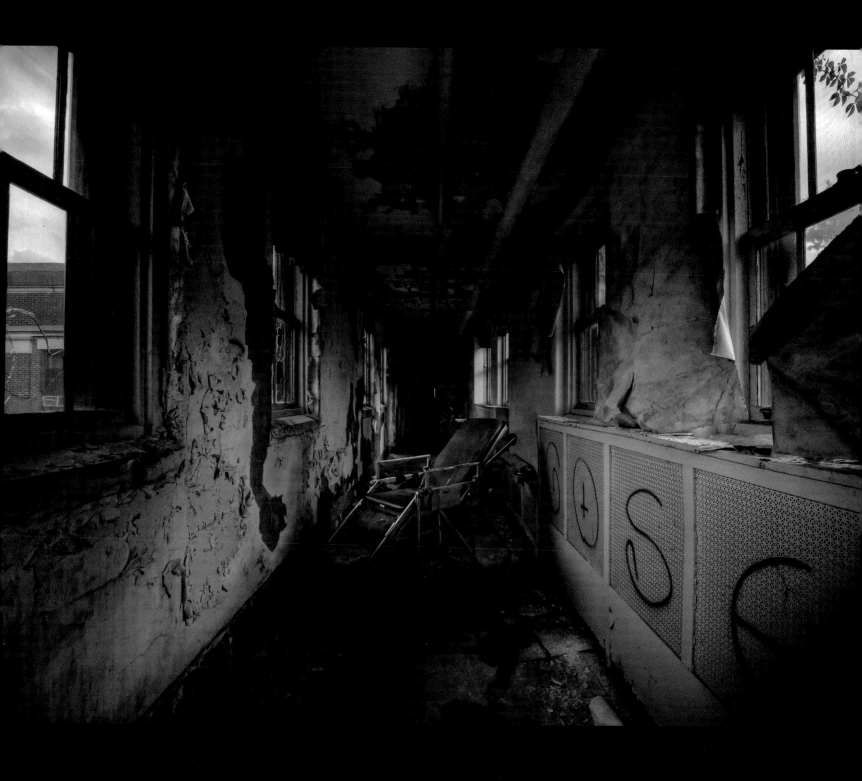

Asylum, New Jersey

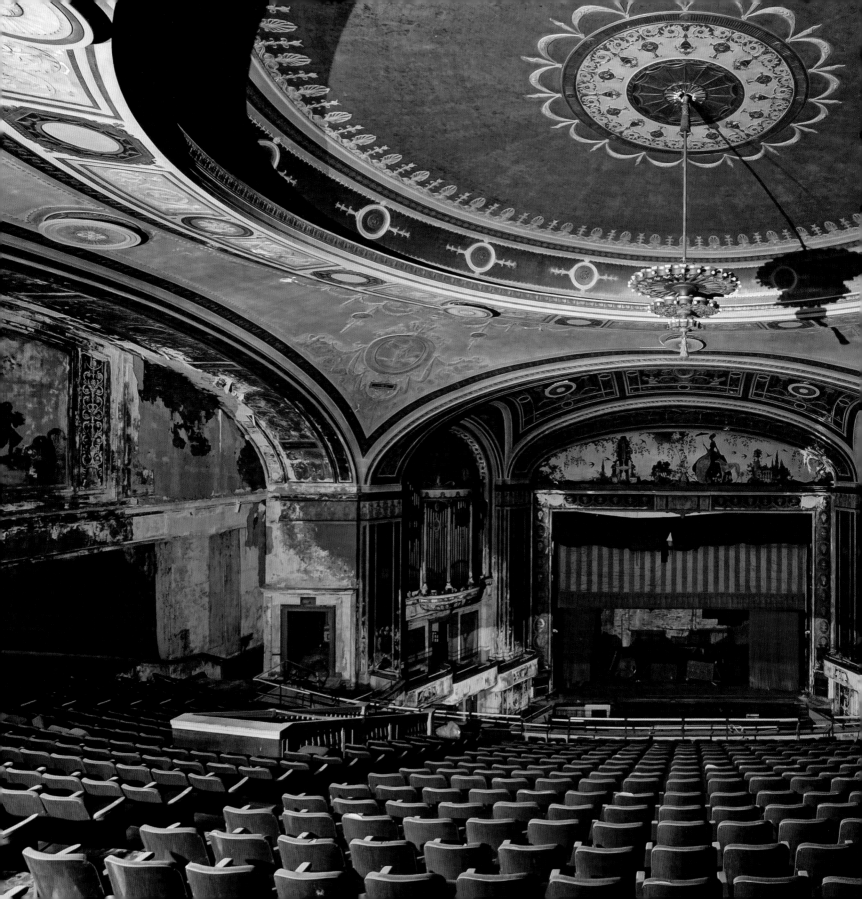

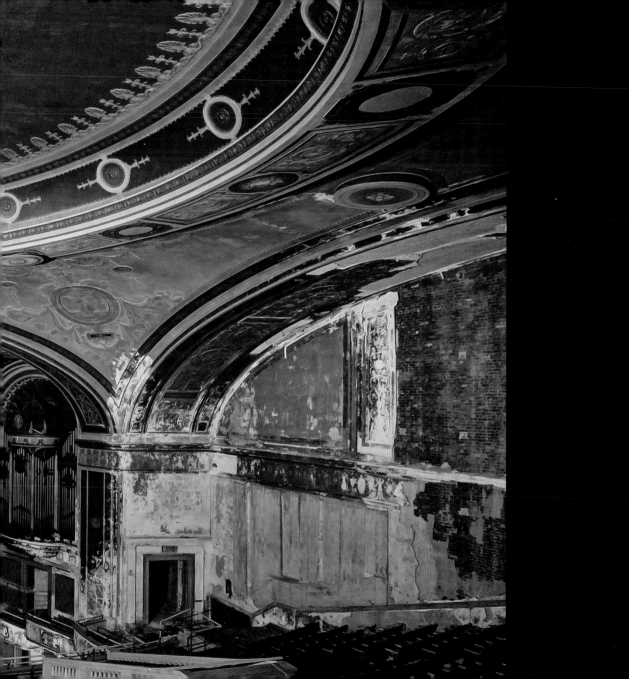

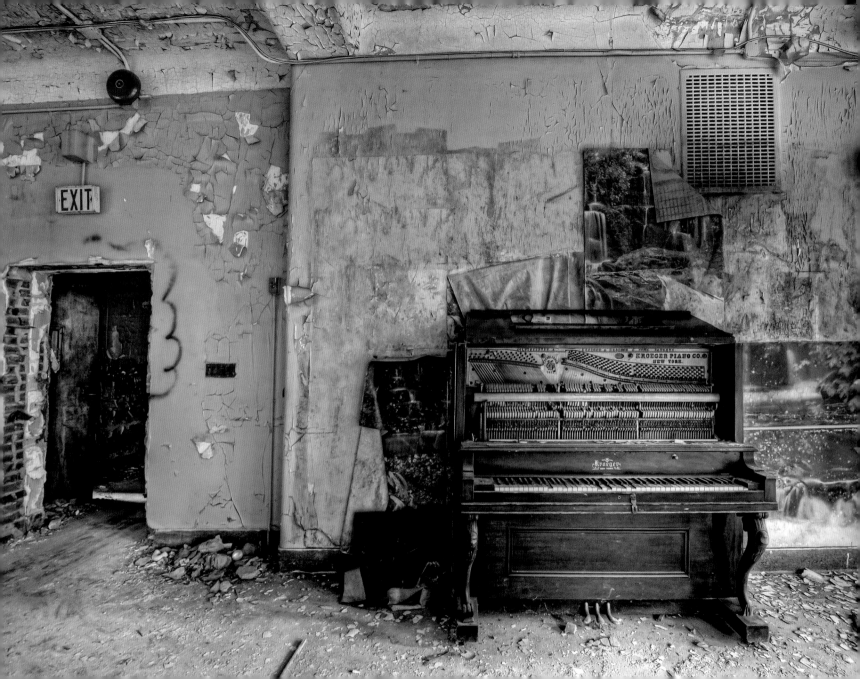

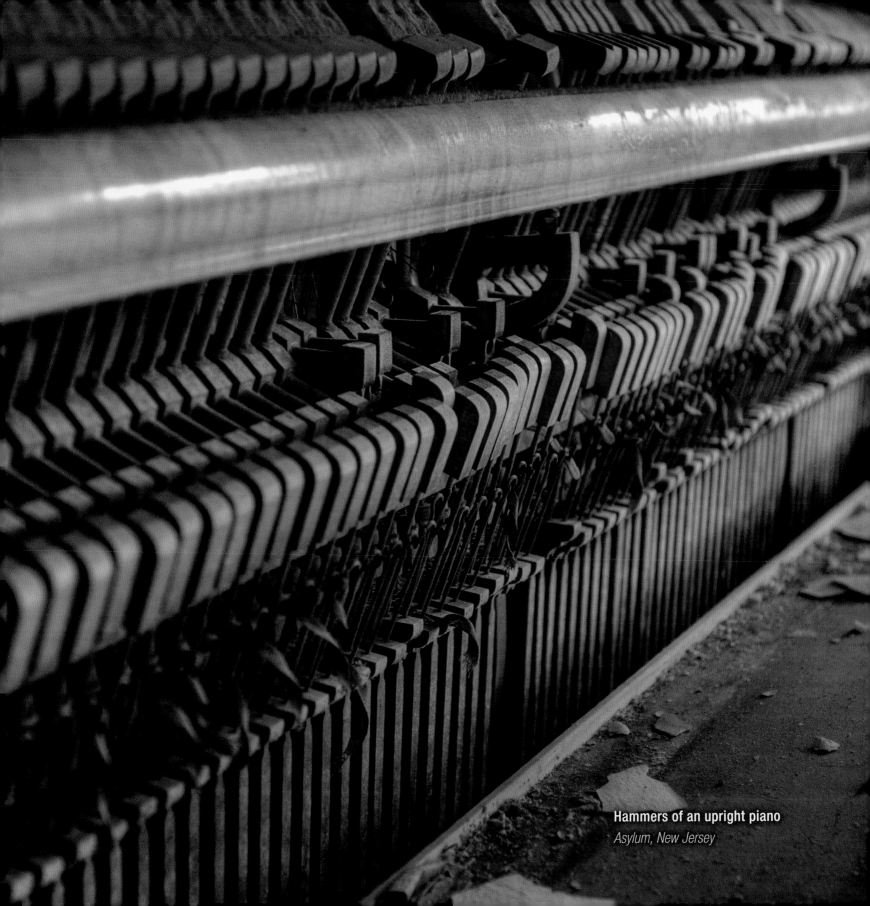

Hammers of an upright piano
Asylum, New Jersey

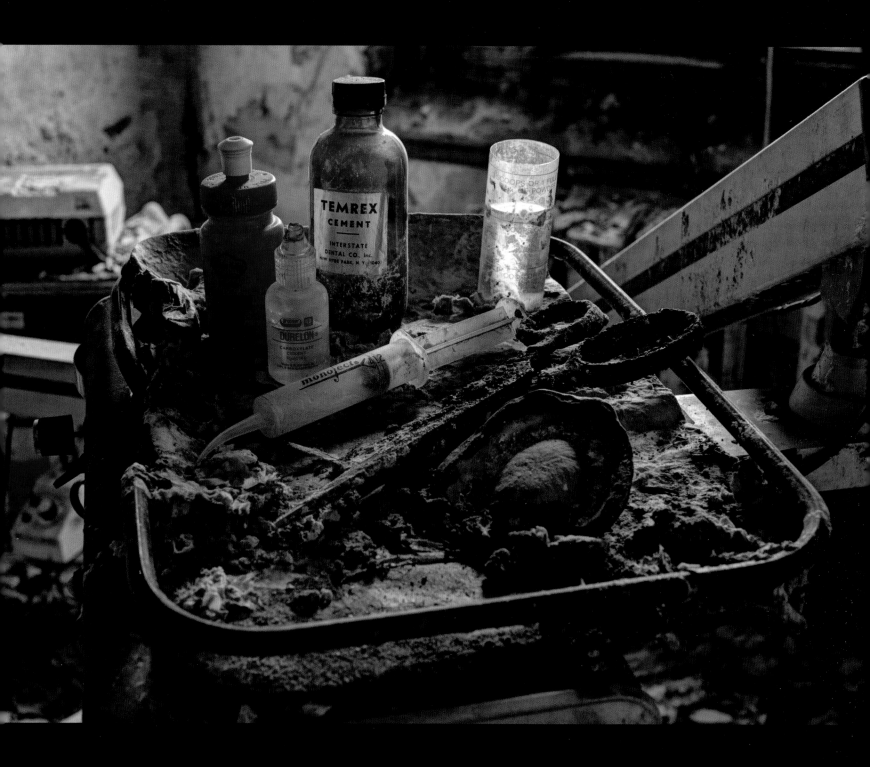

Dental equipment

Asylum, New Jersey

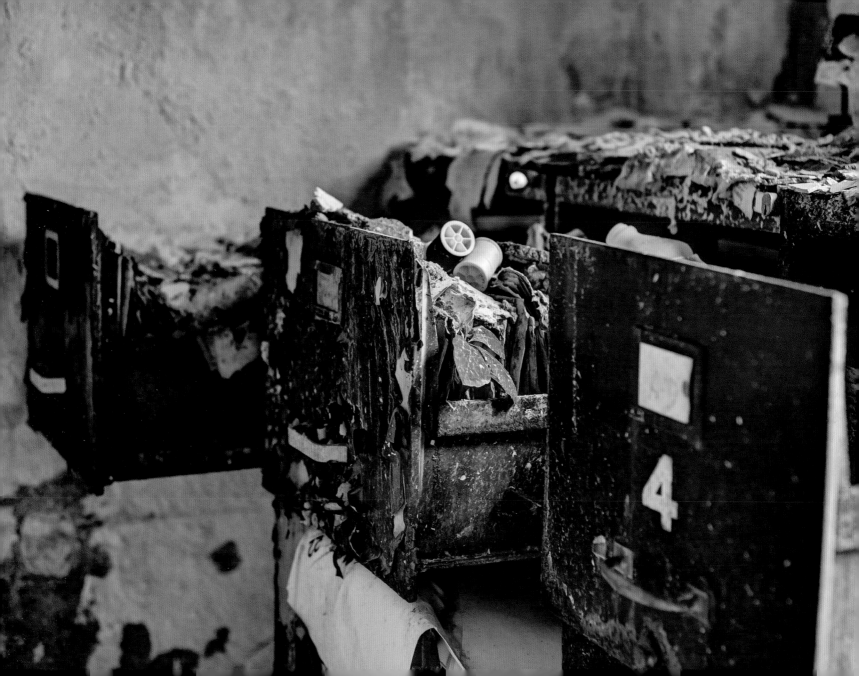

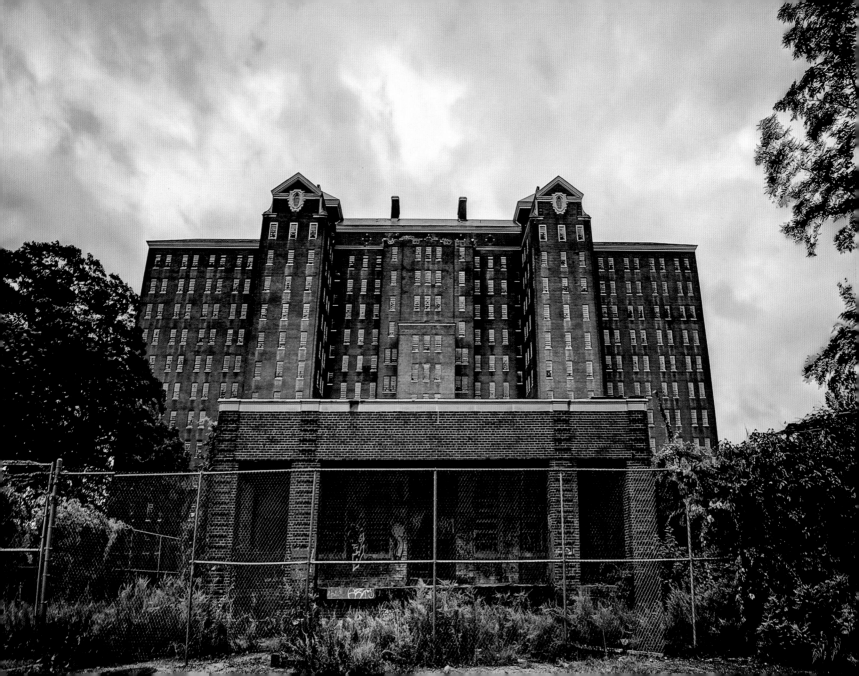

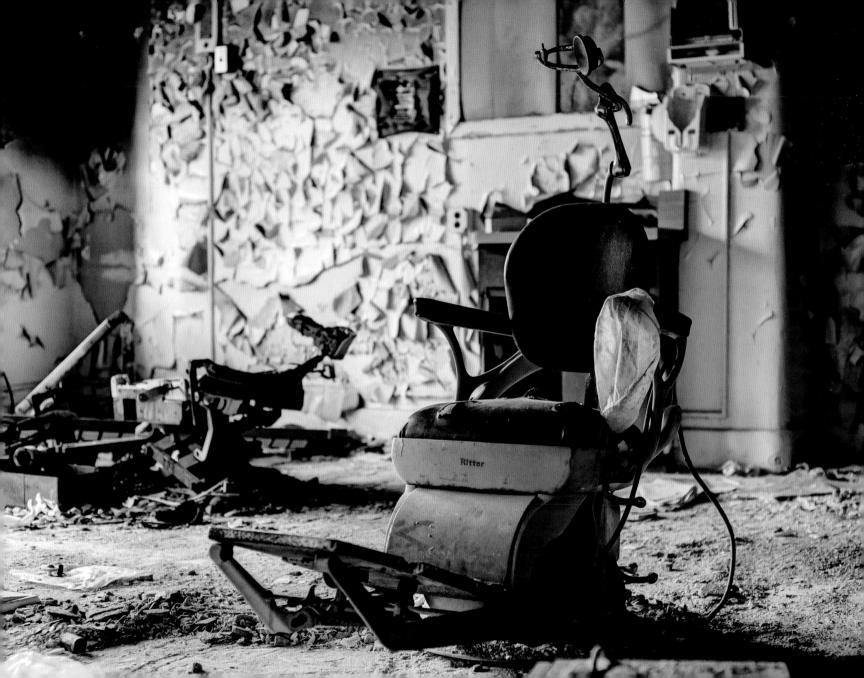

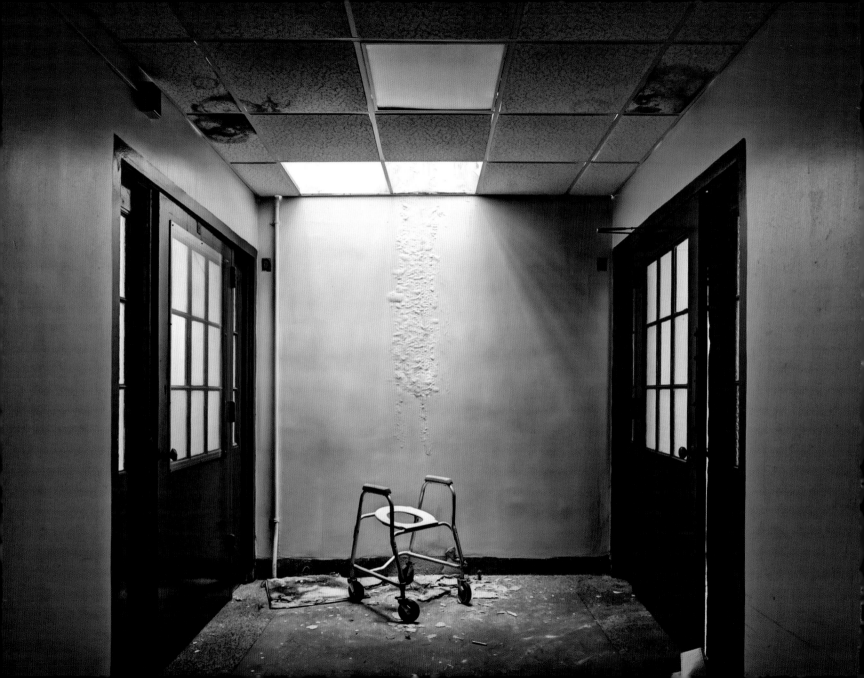

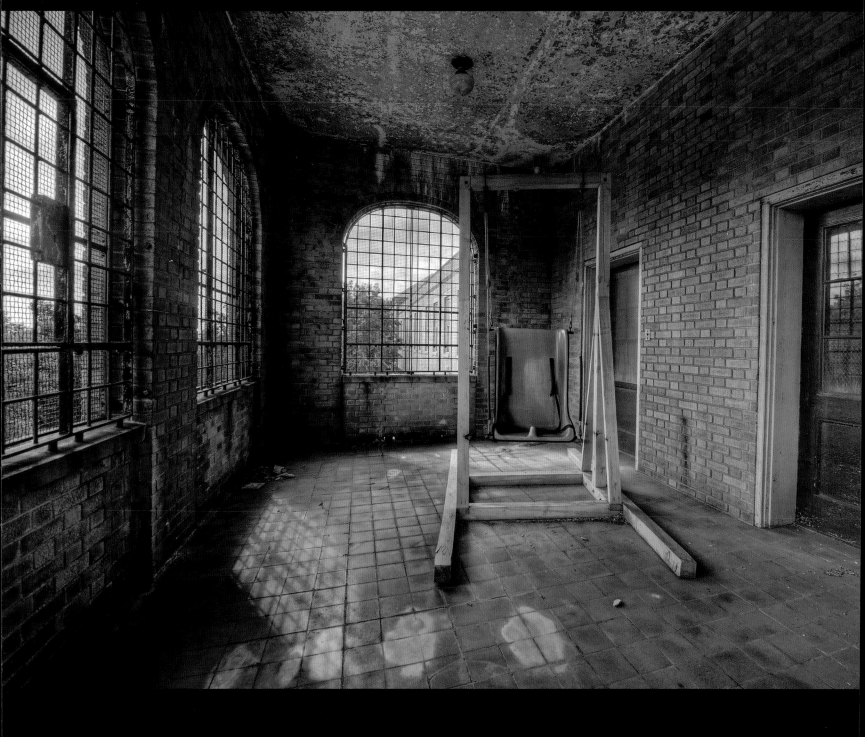

Asylum, New York

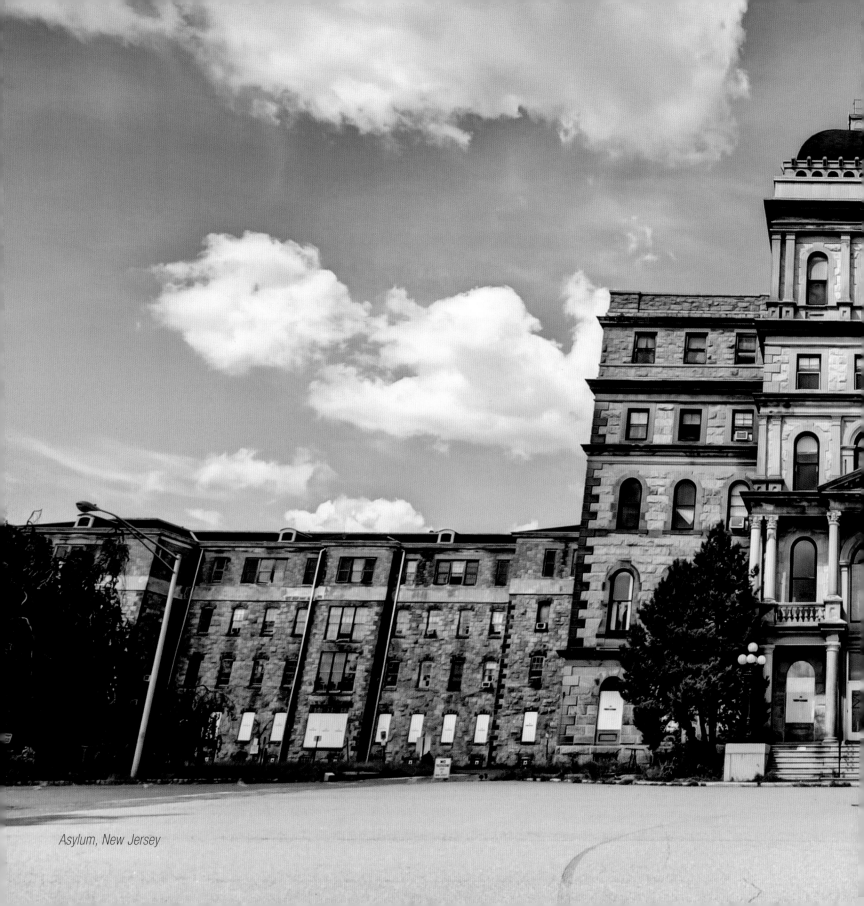

Asylum, New Jersey

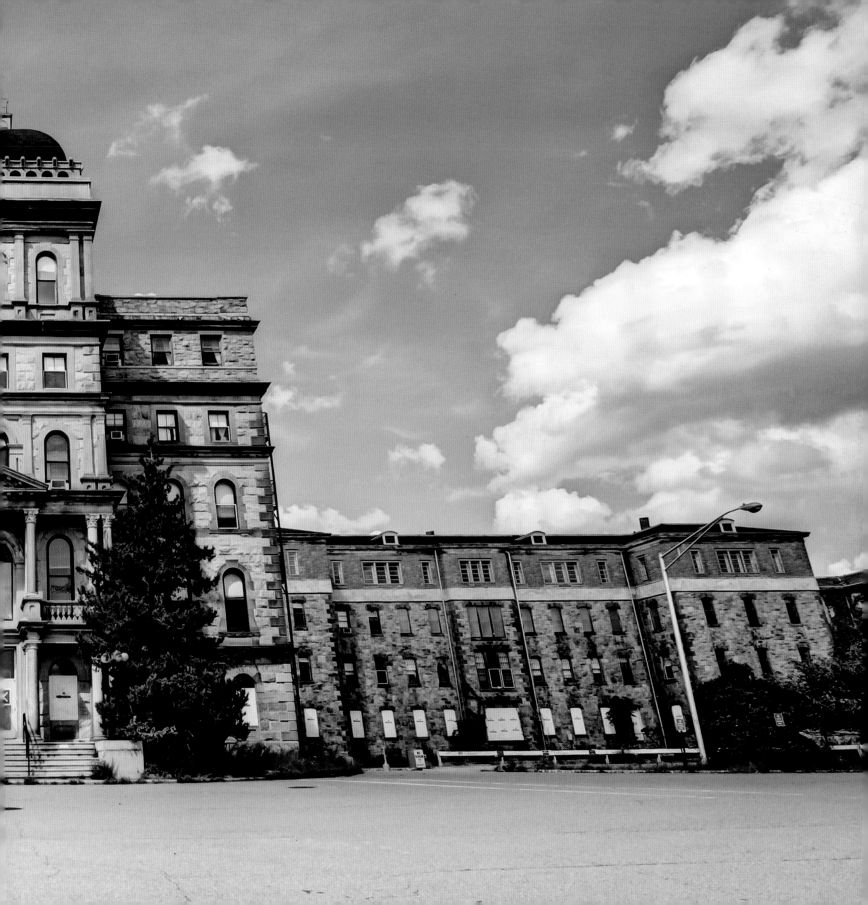

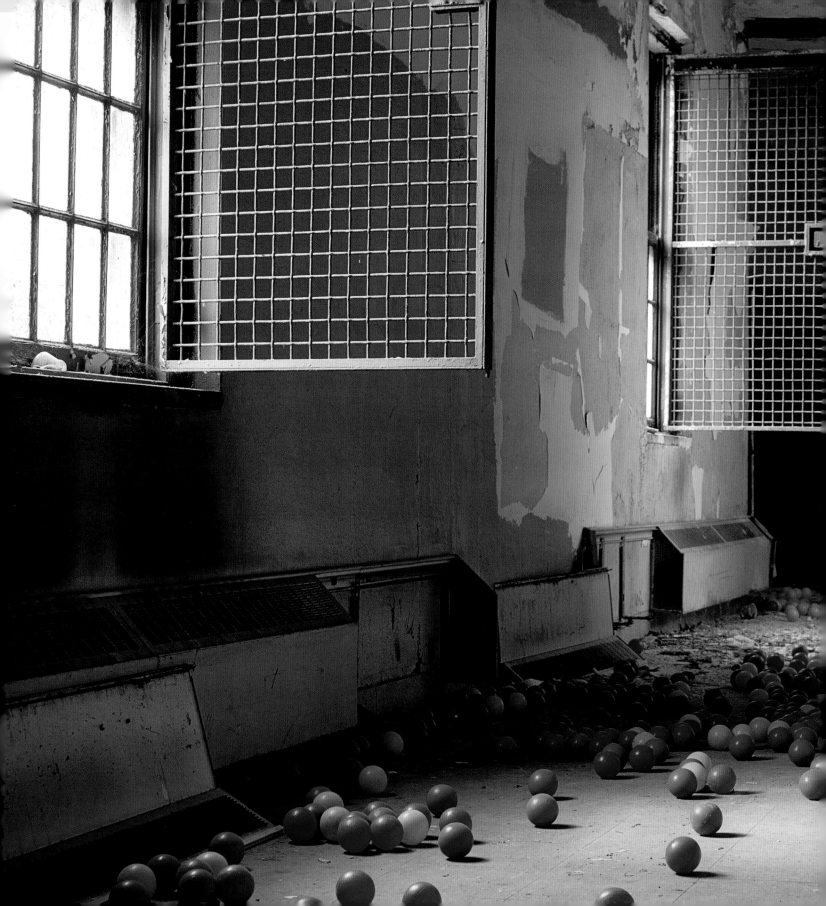

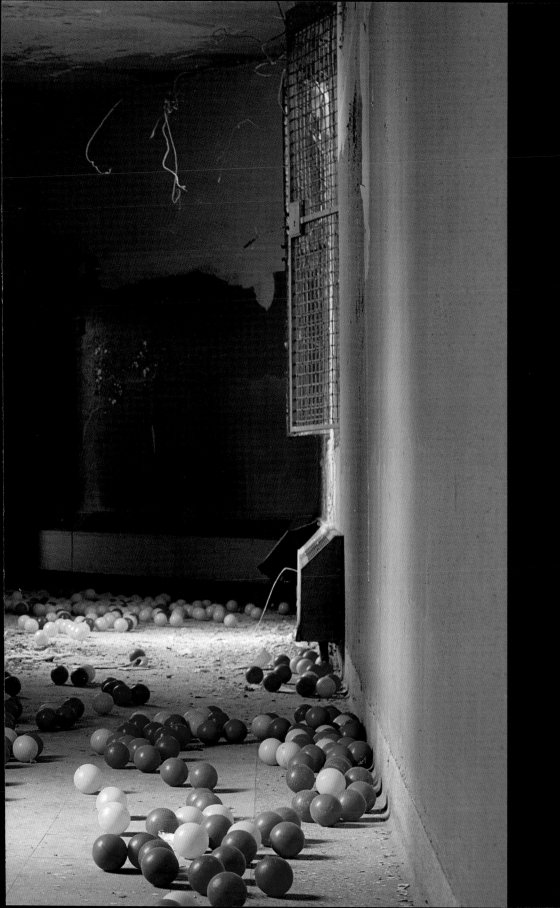

Asylu

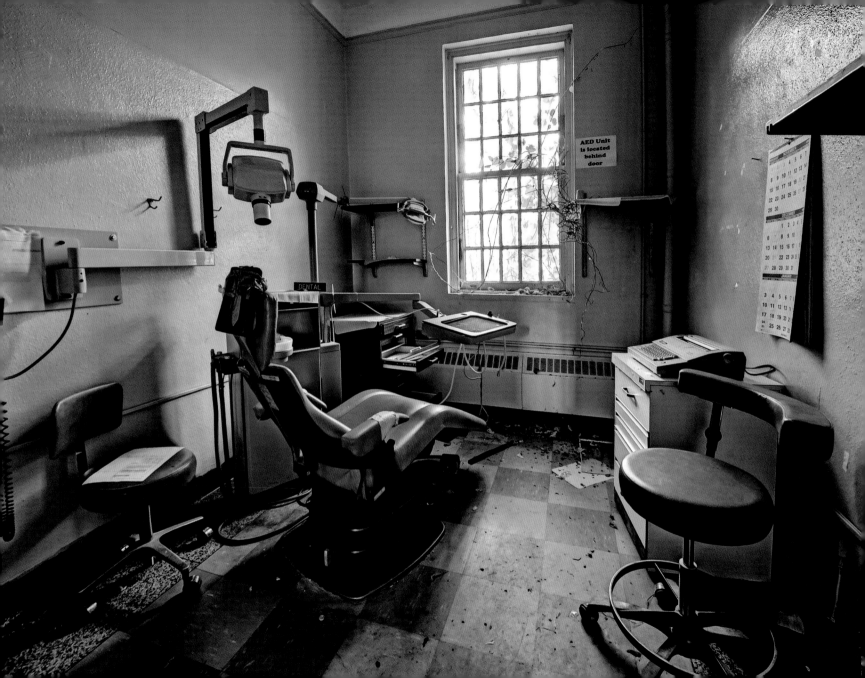

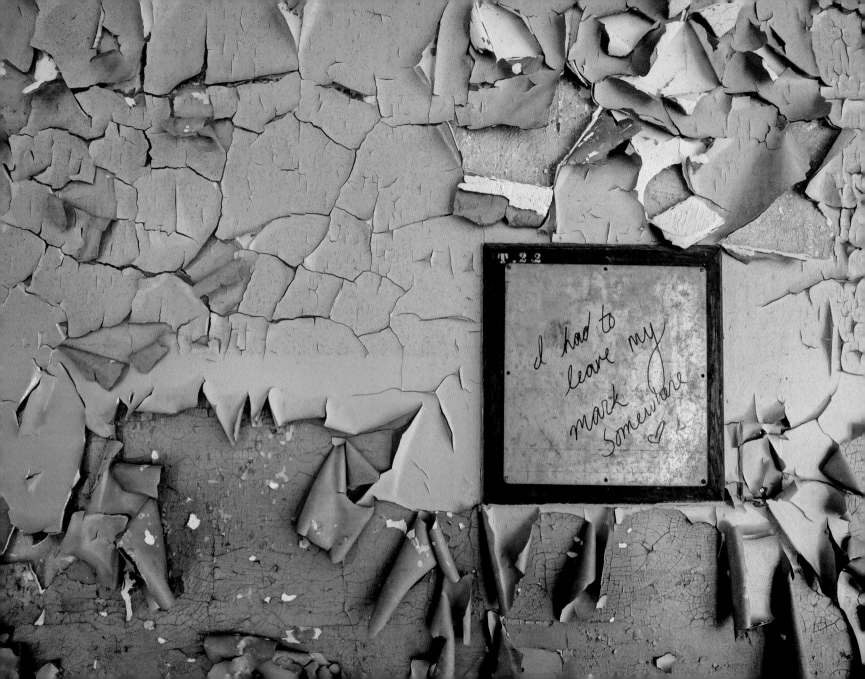

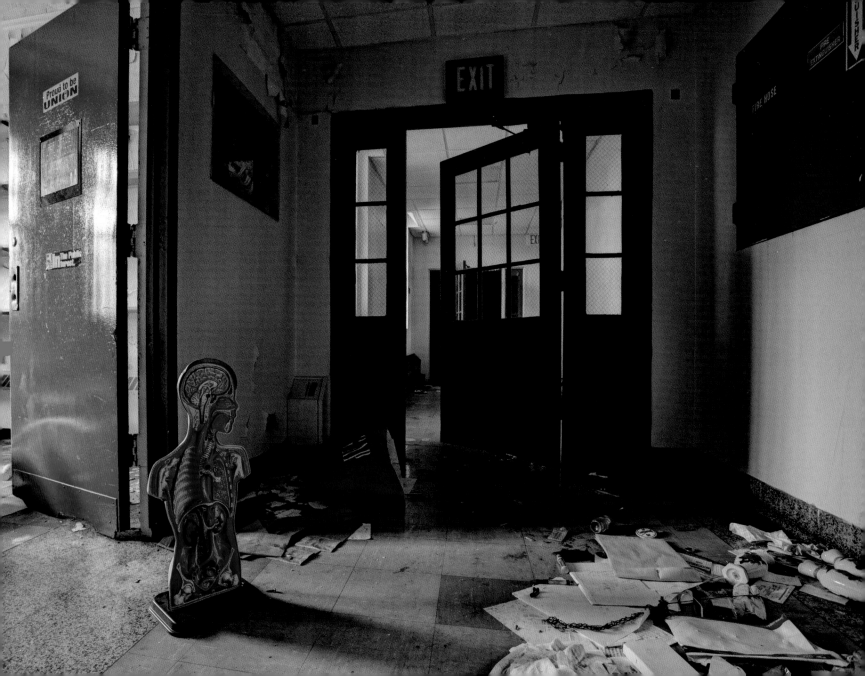

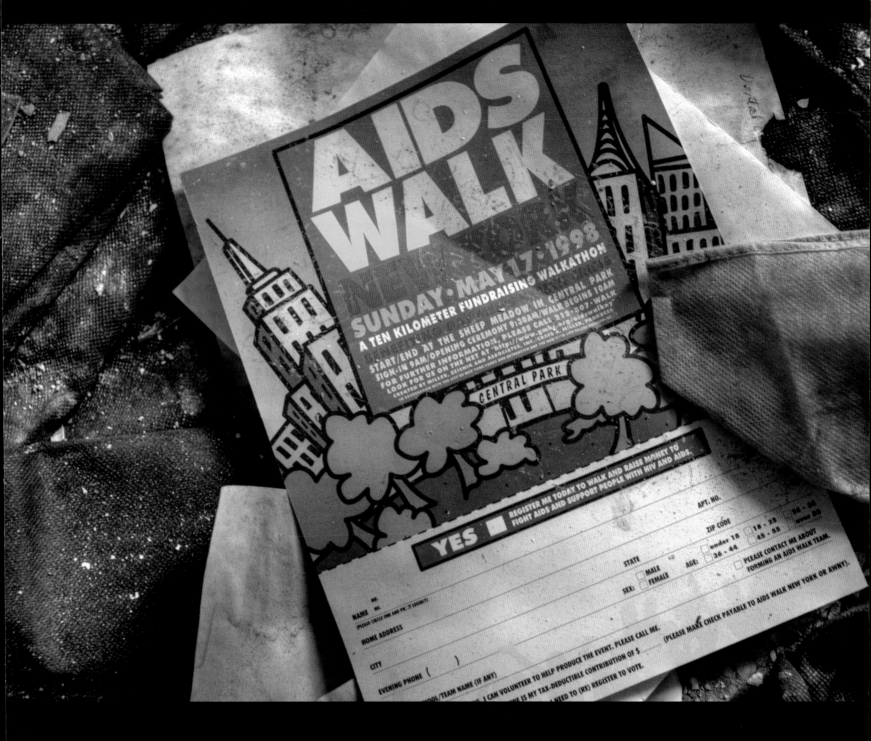

Asylum, New York

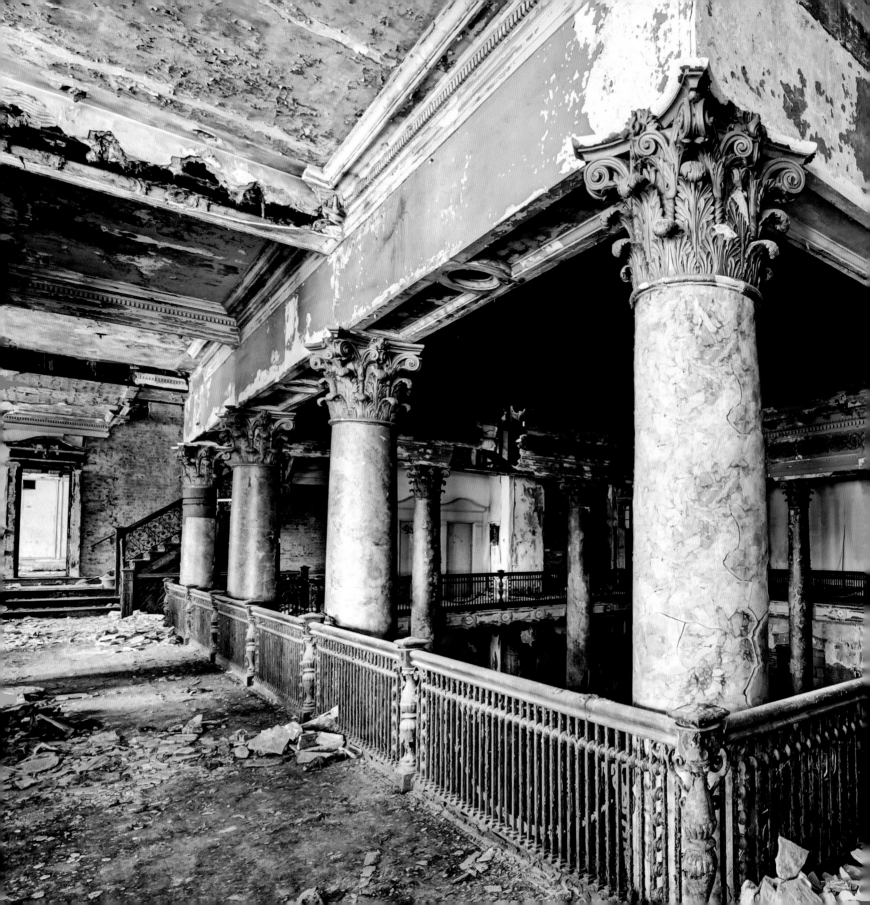

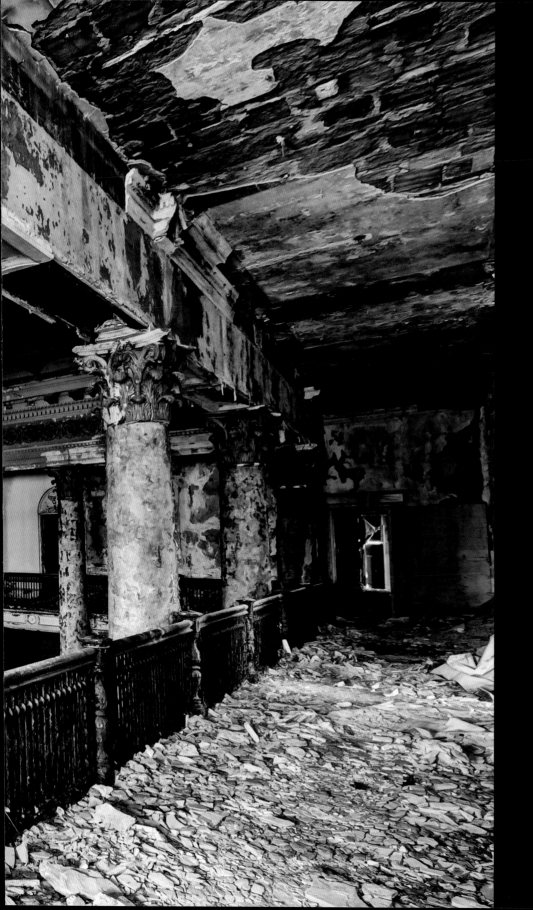

Hotel, Pennsylvania

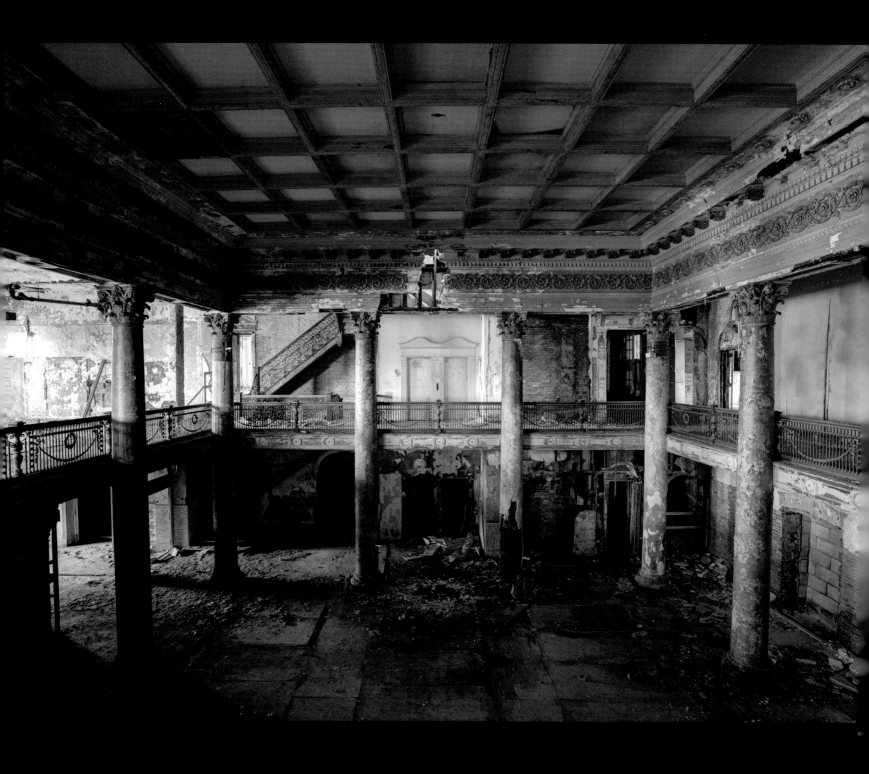

Hotel, Pennsylvania

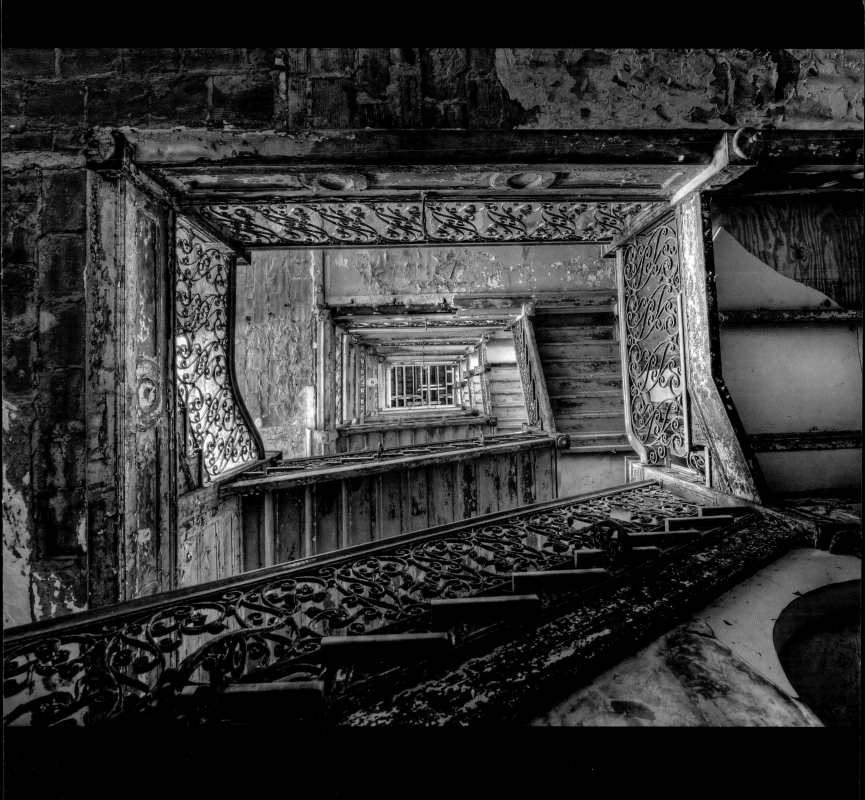

View looking up staircase
Hotel, Pennsylvania

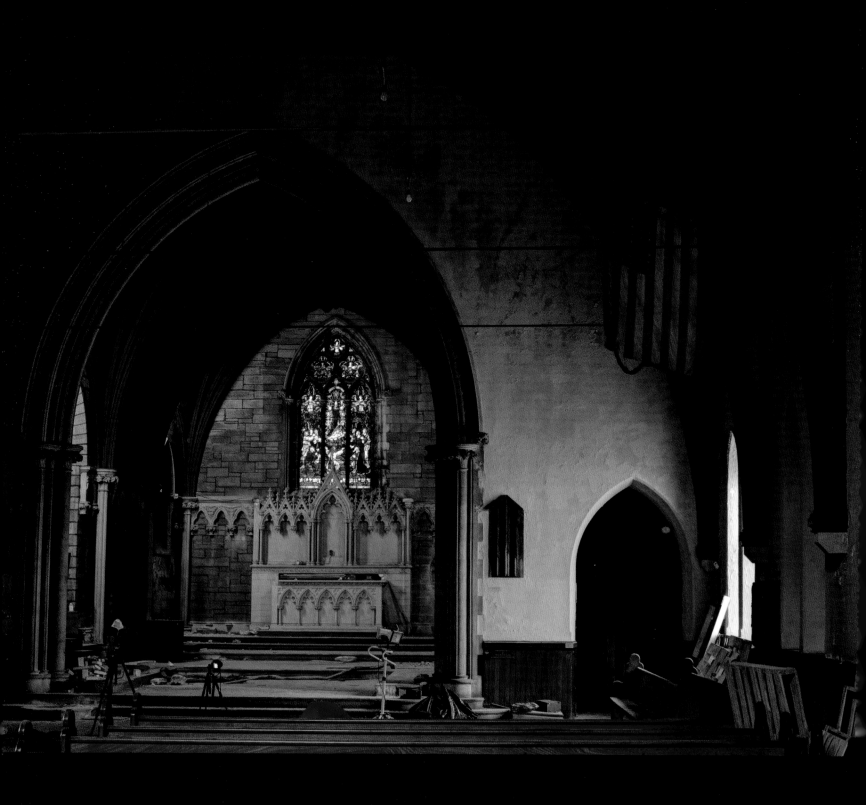

Church, Pennsylvania

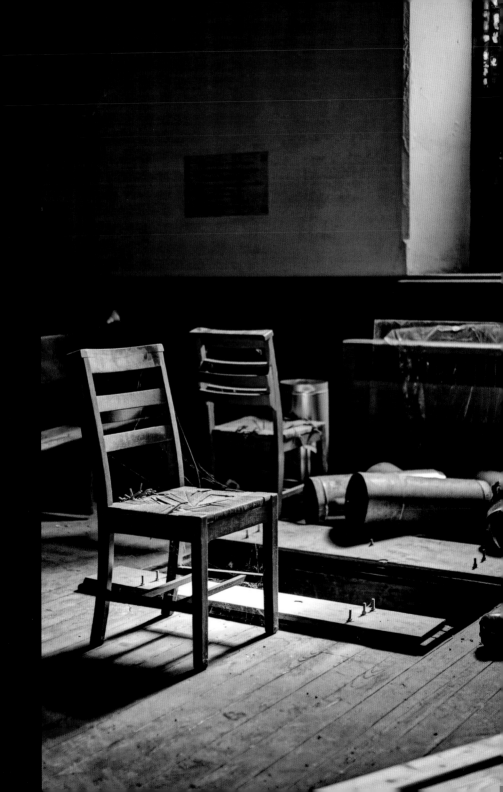

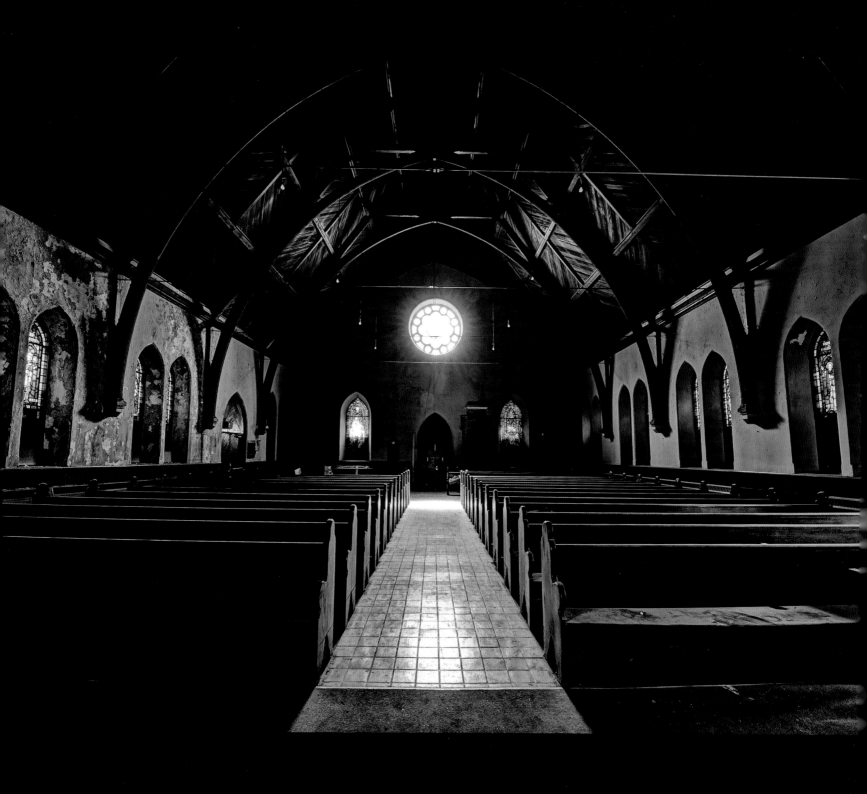

Church, Pennsylvania

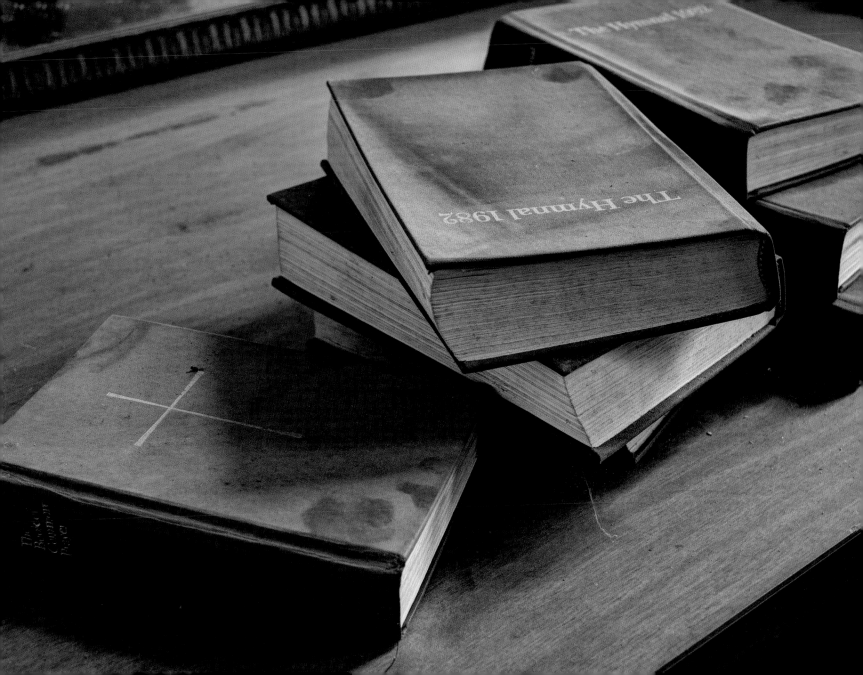

WHY WE DO IT?

There are compelling reasons for people to explore the hidden corners and shadowed fringes of our urban environments. Irrespective of cultures and borders, a common language can be discerned based on the universal and ever-evolving language of photographic expression.

Whilst some might be quick in dismissing Urbex as a shallow pursuit of vicarious thrills, its ideals run deep and share the same philosophical concerns as mainstream photo-journalism. Not only do urban explorers find an aesthetic appeal in the decay, they also acknowledge their role in documenting sites otherwise ignored in order to build an unofficial but vital archival record. Here lies the historical significance of Urbex, which can also be found in other activities to emerge from our concrete jungles, such as parkour, street art, and skate boarding. Those who engage in these creative outlets re-appropriate their urban spaces, claiming ownership of architecture and legal boundaries that cut across class, wealth, and poverty.

It has forever been the case that locations with architectural and historical significance are abandoned to wrack and ruin by cities that do not have the resources or will to preserve them. The exploration of these concrete corpses allows society to reconnect with its past through the objects found and the suggestions of stories left behind. It is possible to understand the past more intimately by interpreting the relics and ephemera left behind in the everyday comings and goings of previous generations.

The modern urban ruin, unlike the traditional perception of heritage institutions, can provide a stimulating experience for the curious. They are free from artificial narratives, and the stage-managed recreation of a period common in museums and stately homes. As they are free to enter, they are also truly democratic. For the explorer, they provide the perfect outlet for an inherent urge to discover the new, and to construct a code based on assuming responsibility for one's owns safety, actions, obligations, and art.

Urban explorers are a growing minority containing the curious, the adrenaline junkies, the talented, and those who are in search of an authentic experience. In the farthest reaches of our cities, they secretly wander, jump, run, climb, touch, transgress …

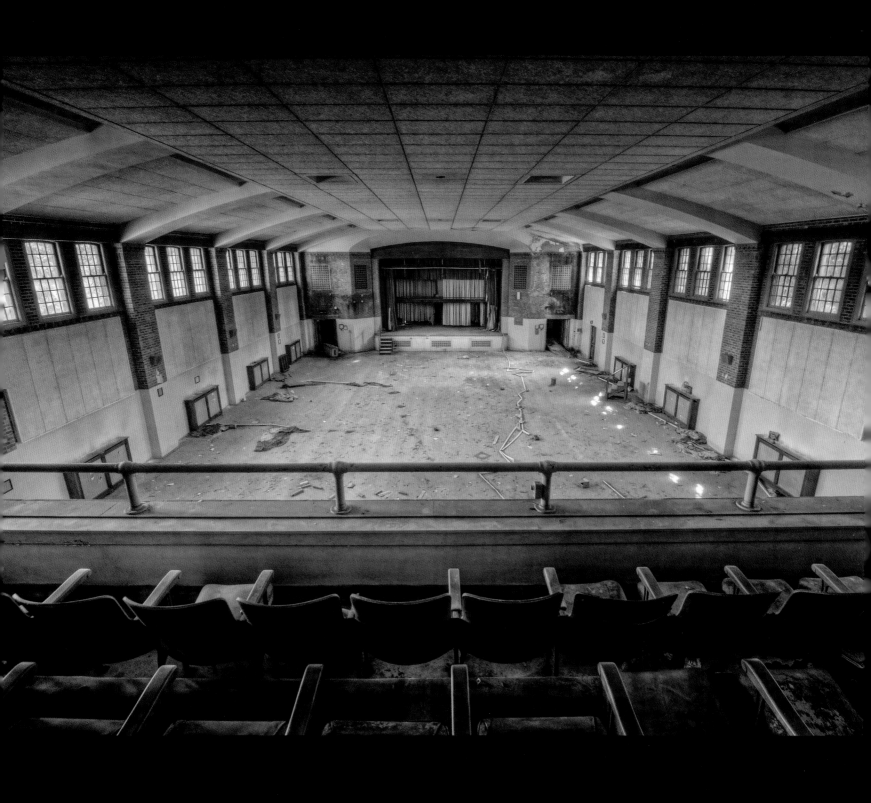

Asylum, New York

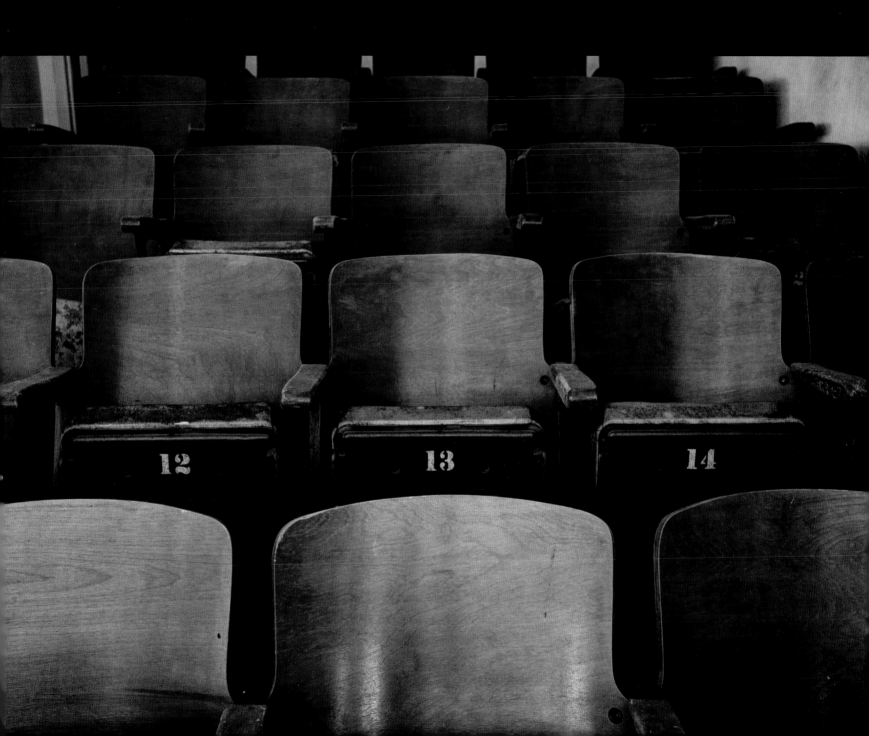

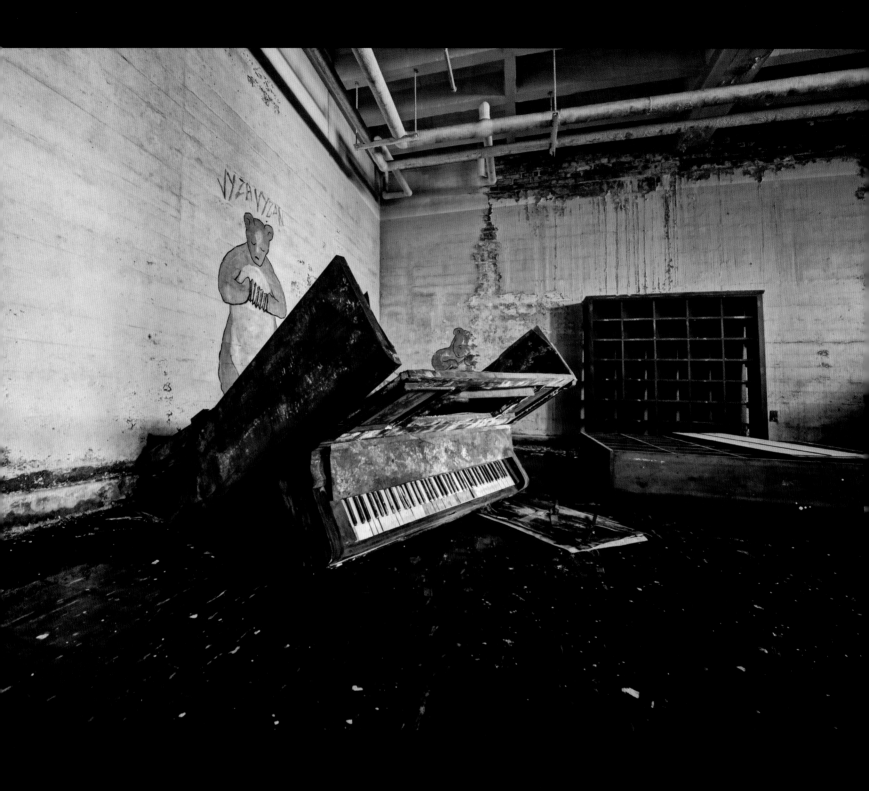

Asylum, New York

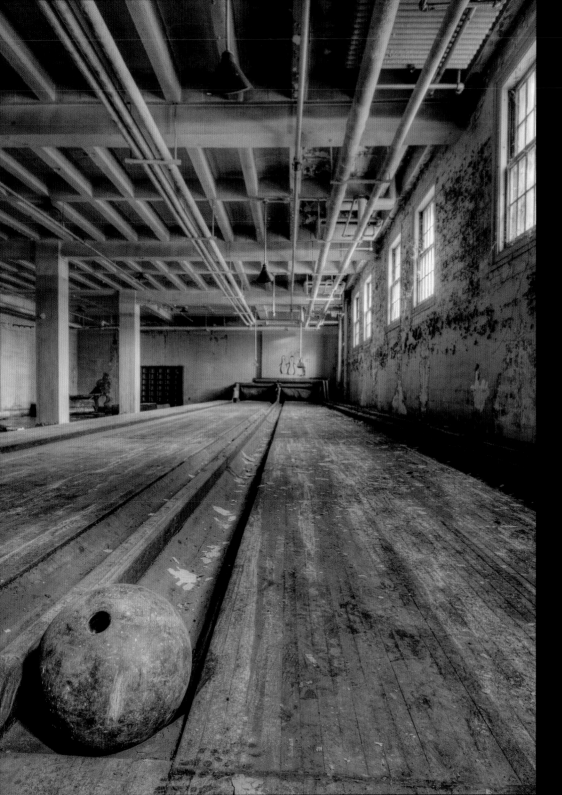

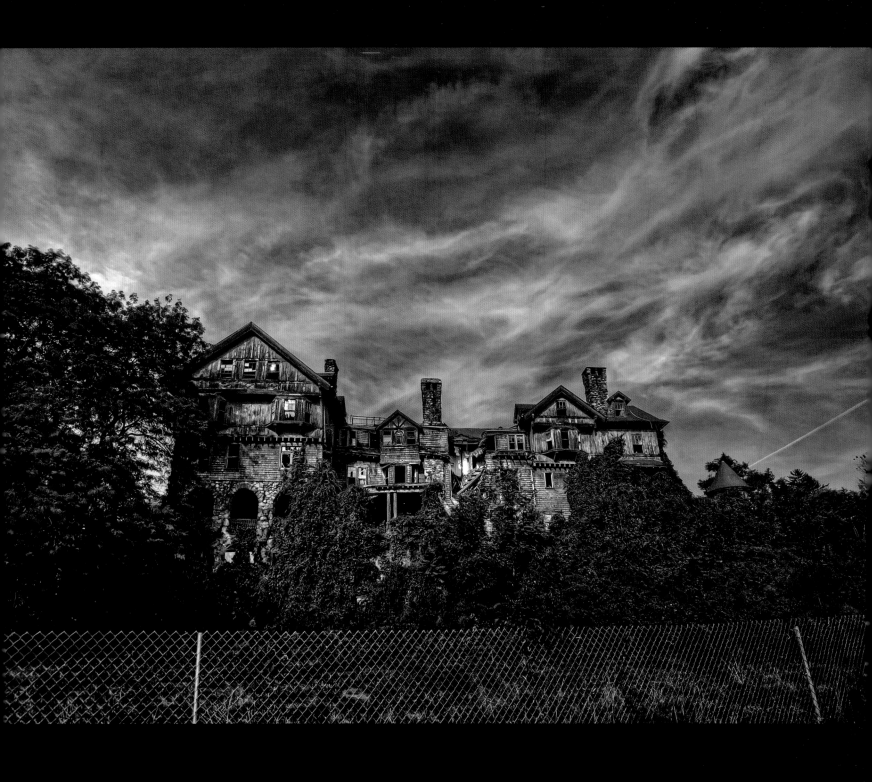

School for girls, New York

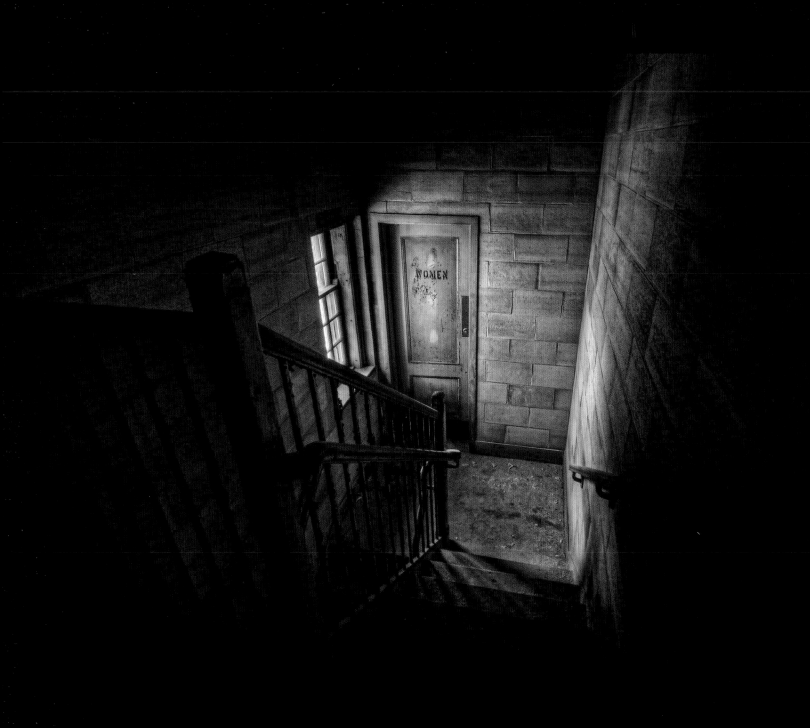

Asylum, New York

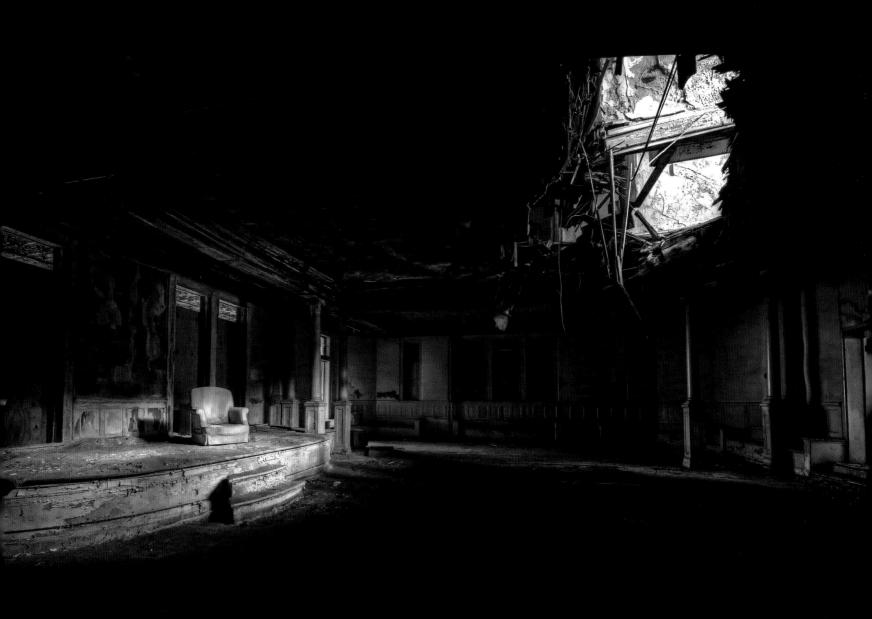

School for girls, New York

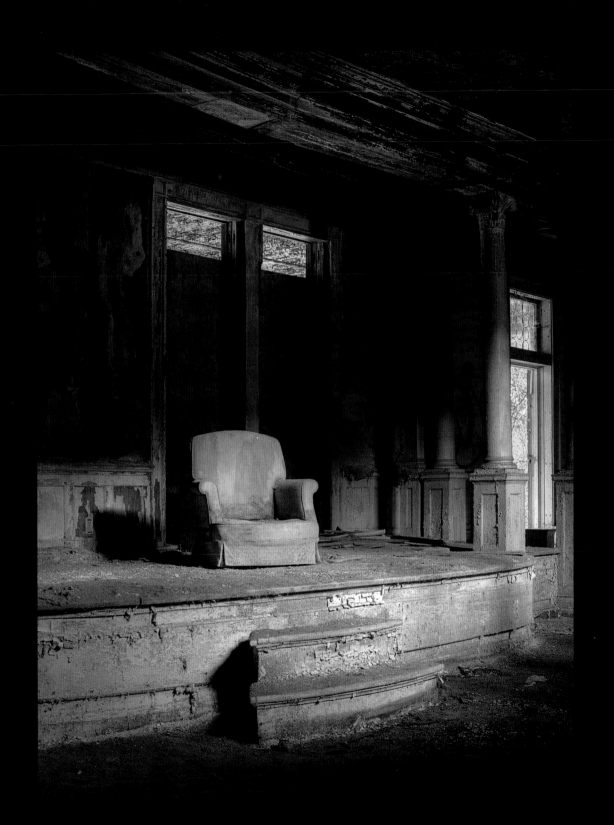

School for girls, New York

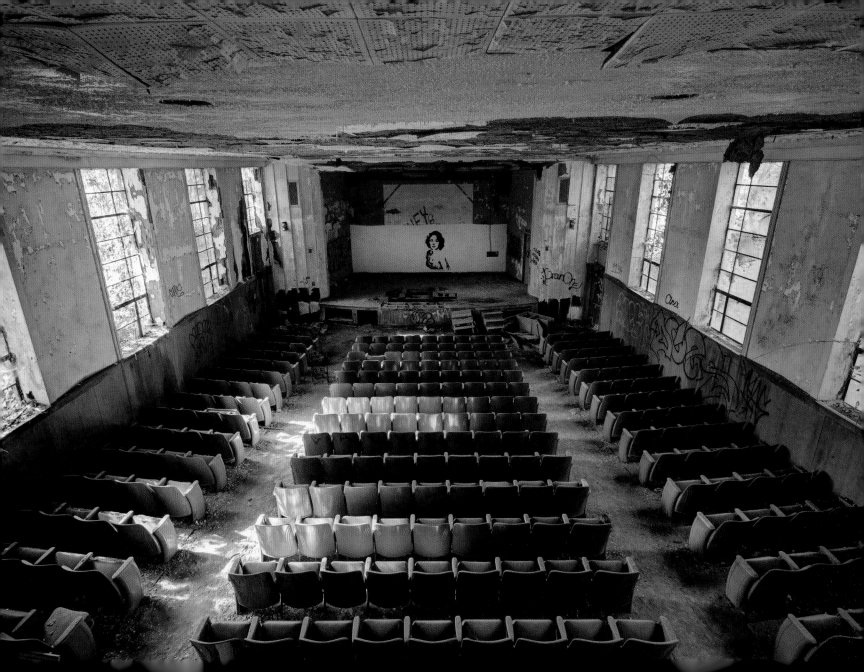

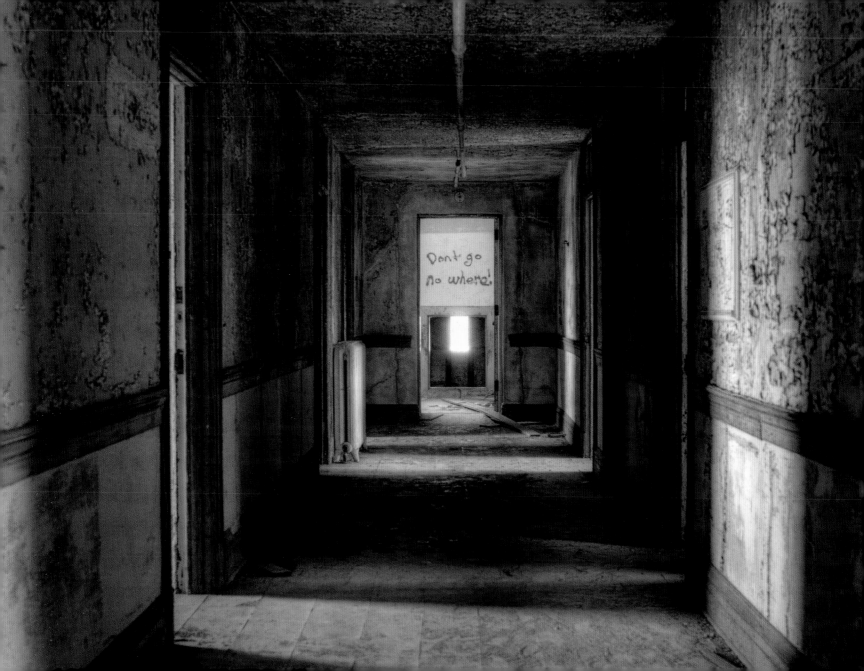

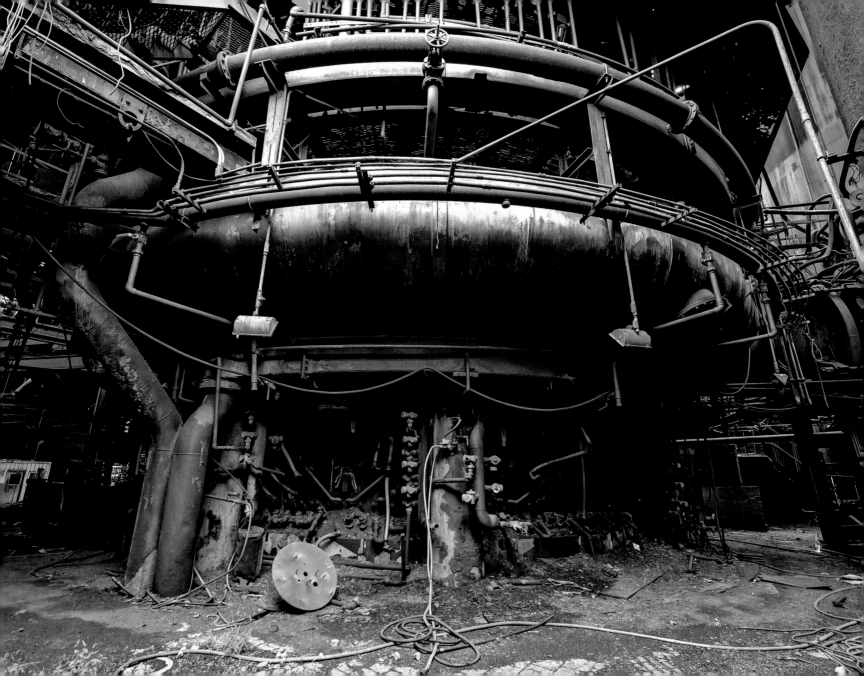

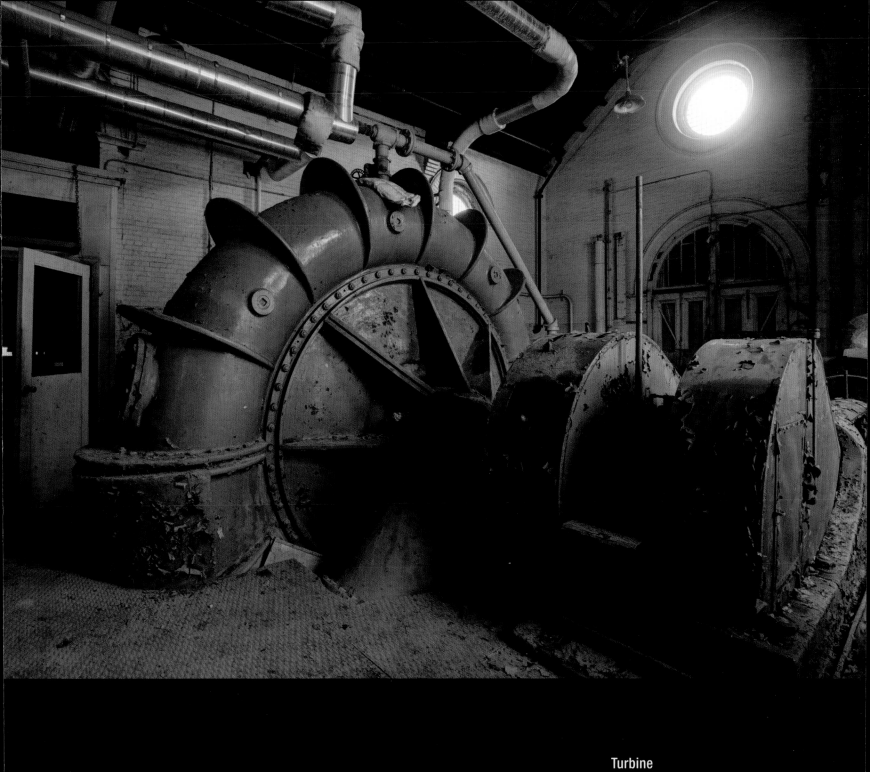

Turbine
Waterworks, New Jersey

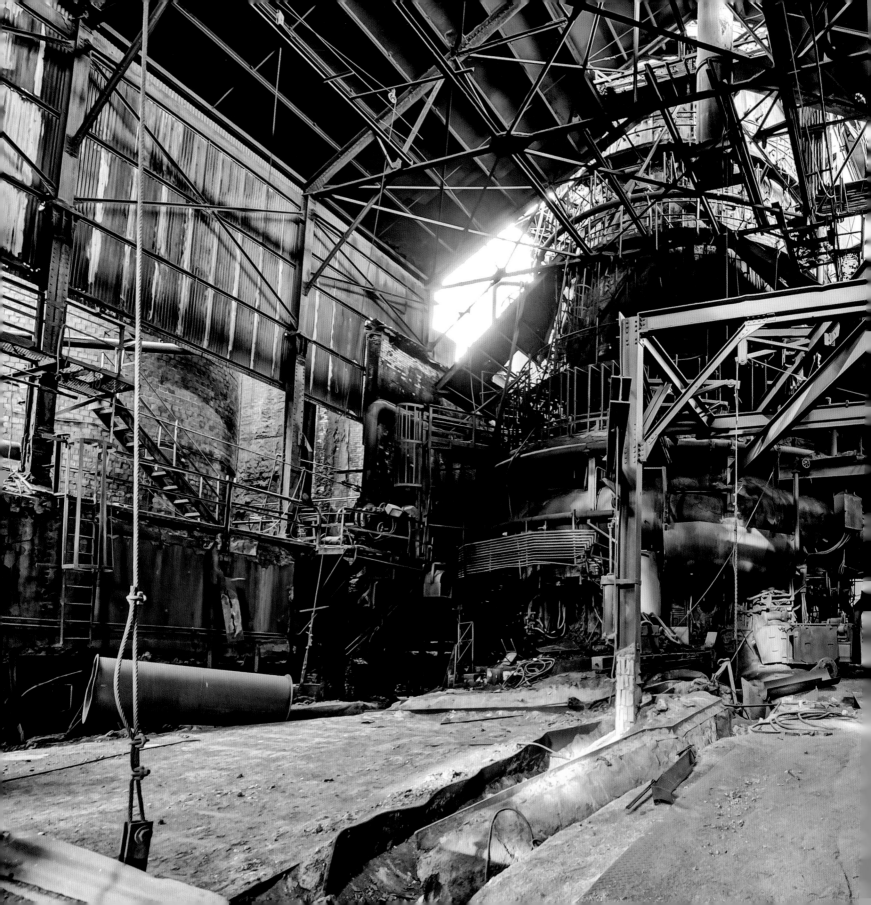

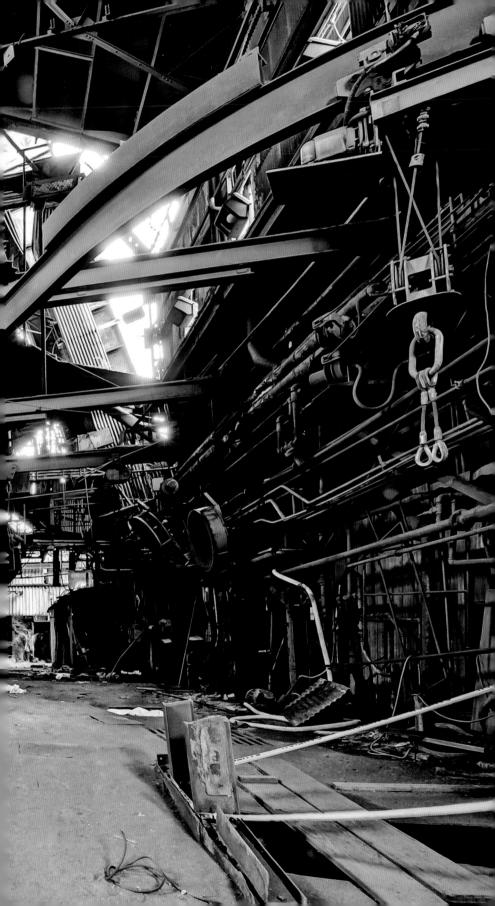

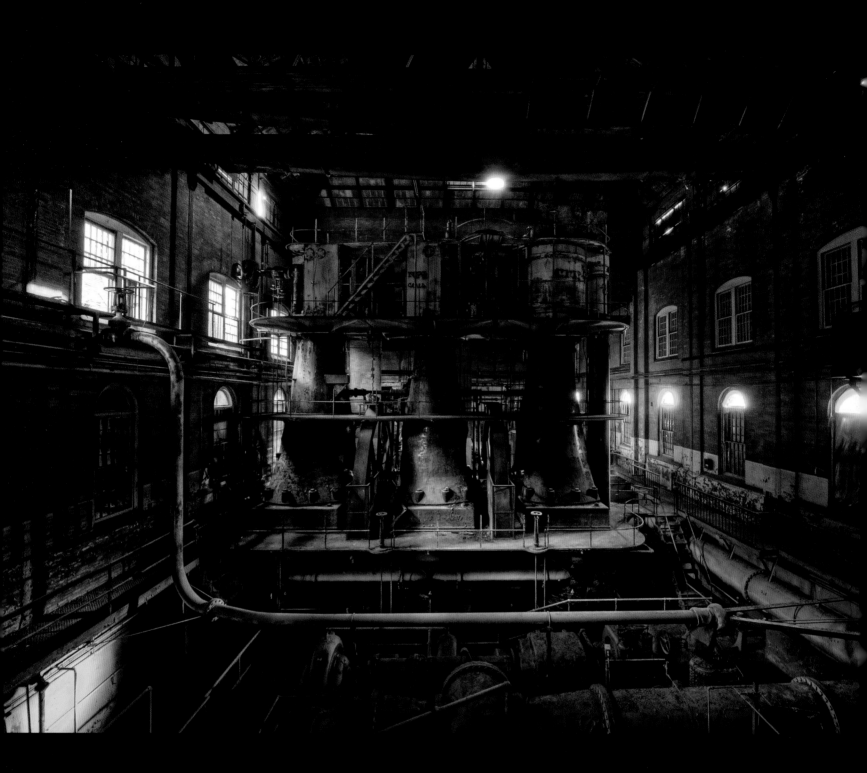

Triple expansion steam engine
Waterworks, New Jersey

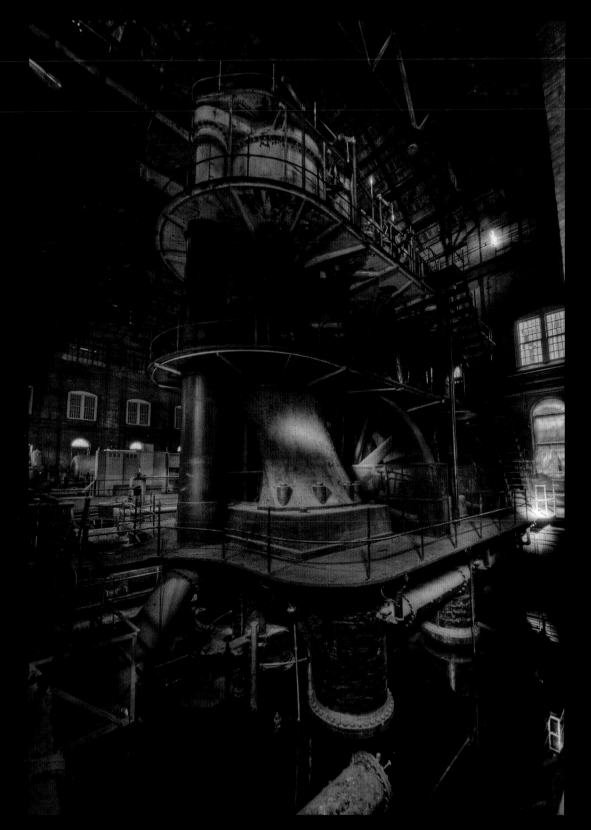

Triple expansion steam engine
Waterworks, New Jersey

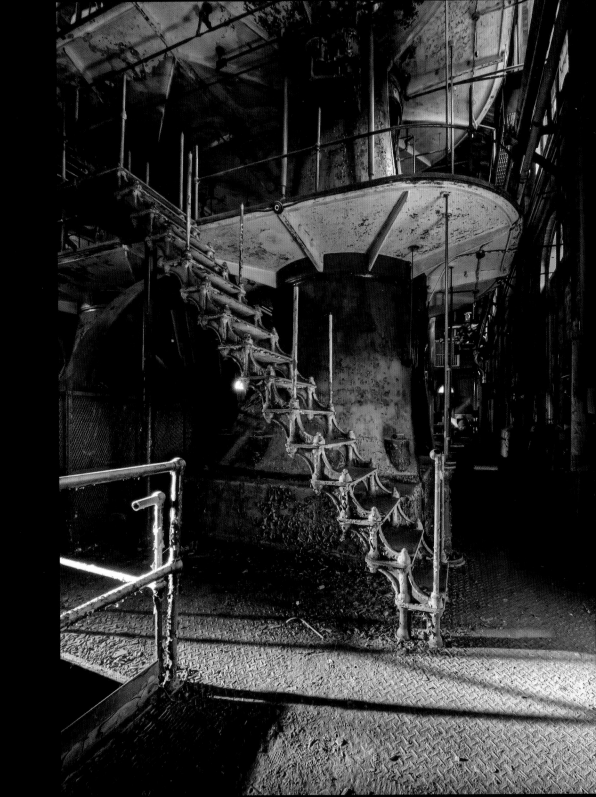

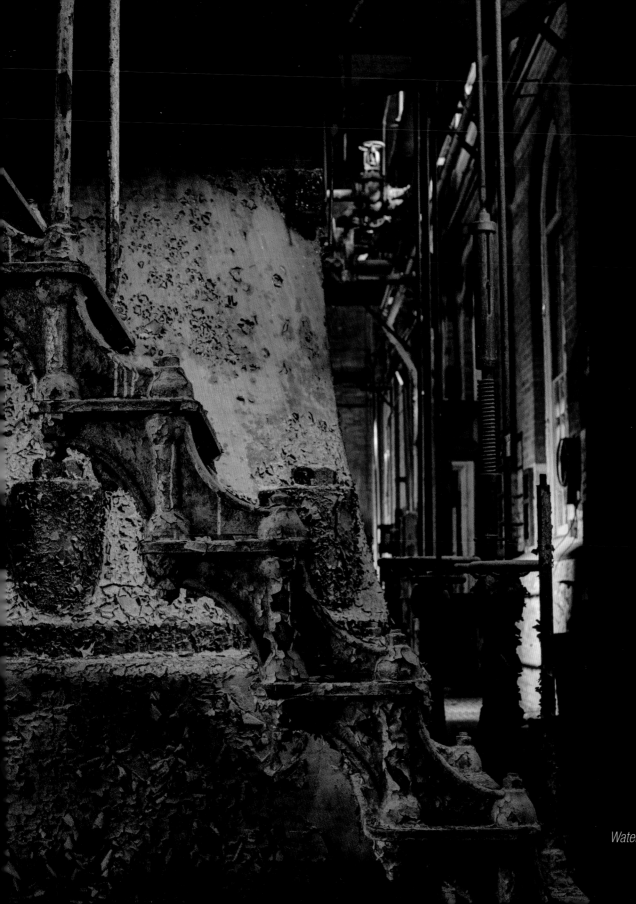

Waterworks, New Jersey

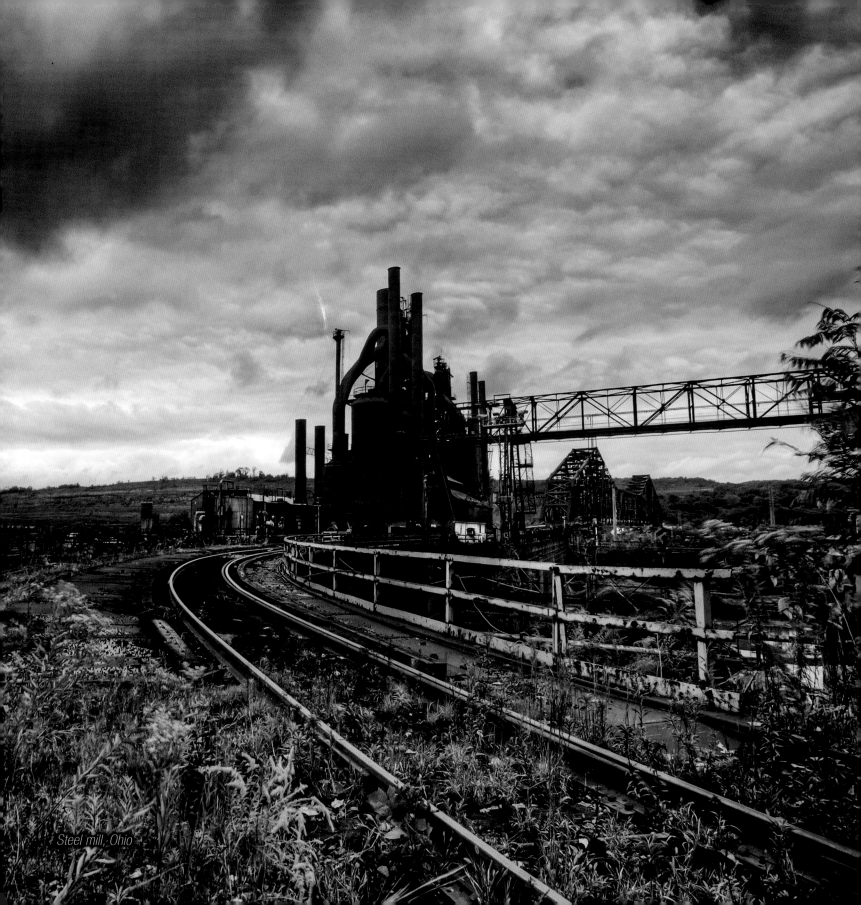

Steel mill, Ohio

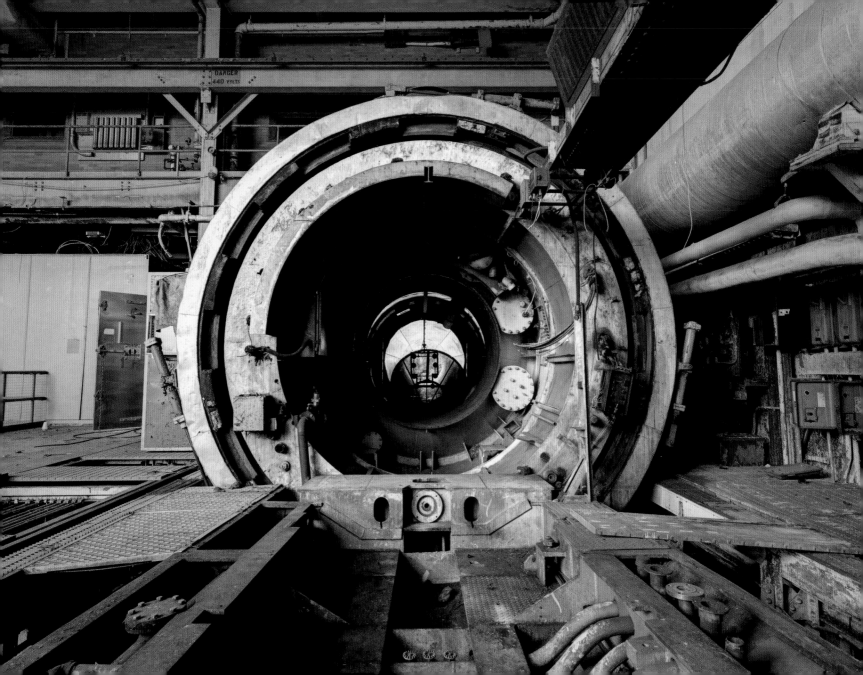

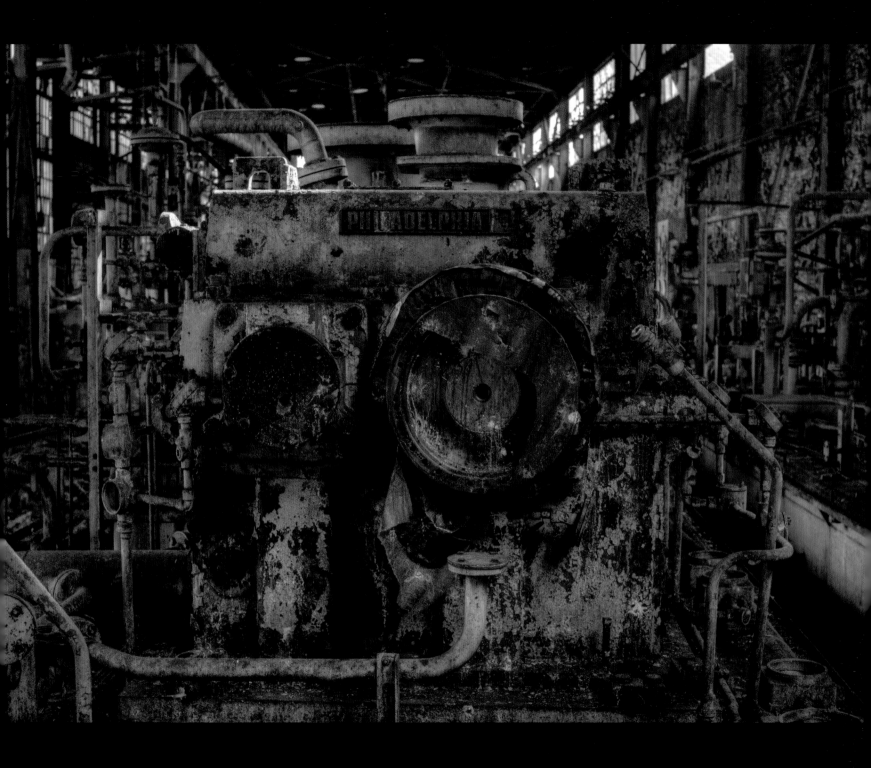

Factory, New York

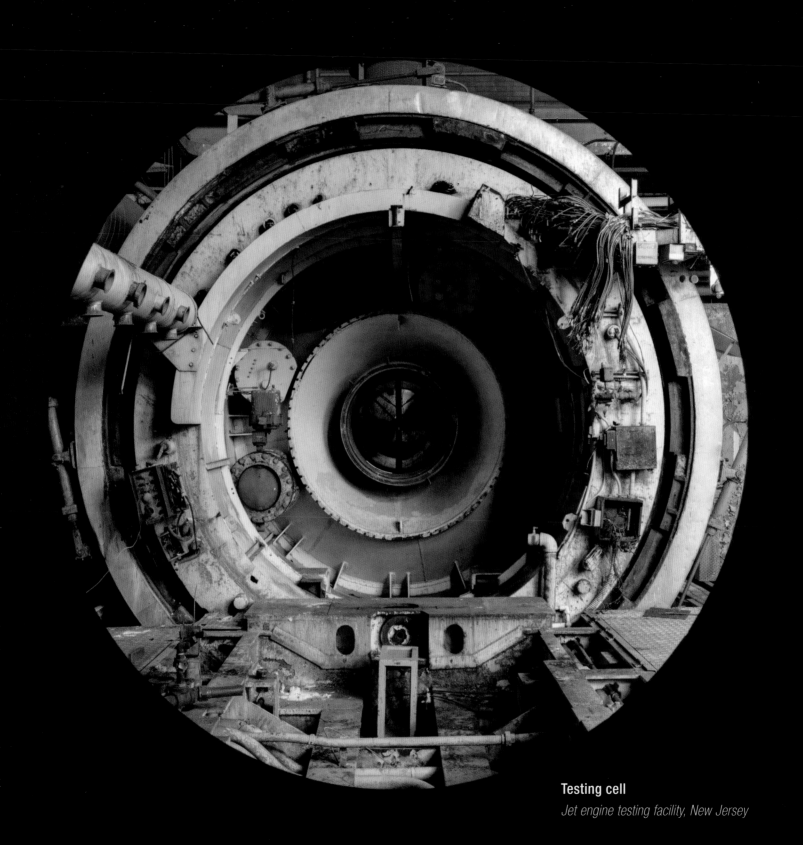

Testing cell

Jet engine testing facility, New Jersey

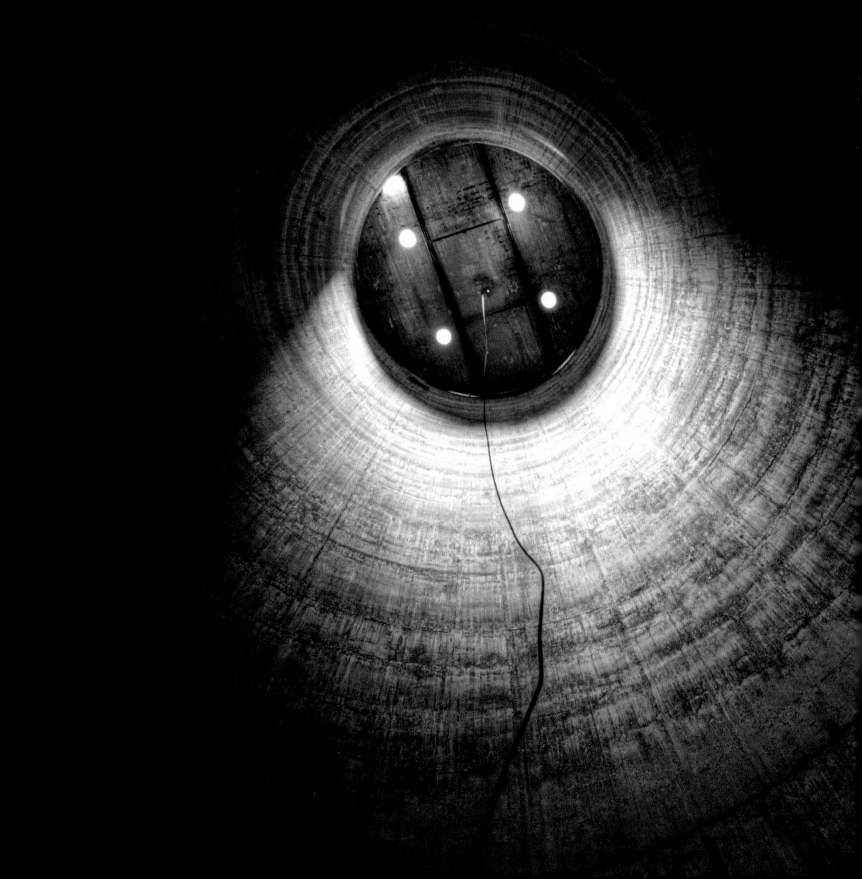

Grain storage silo
Grain elevator, New York

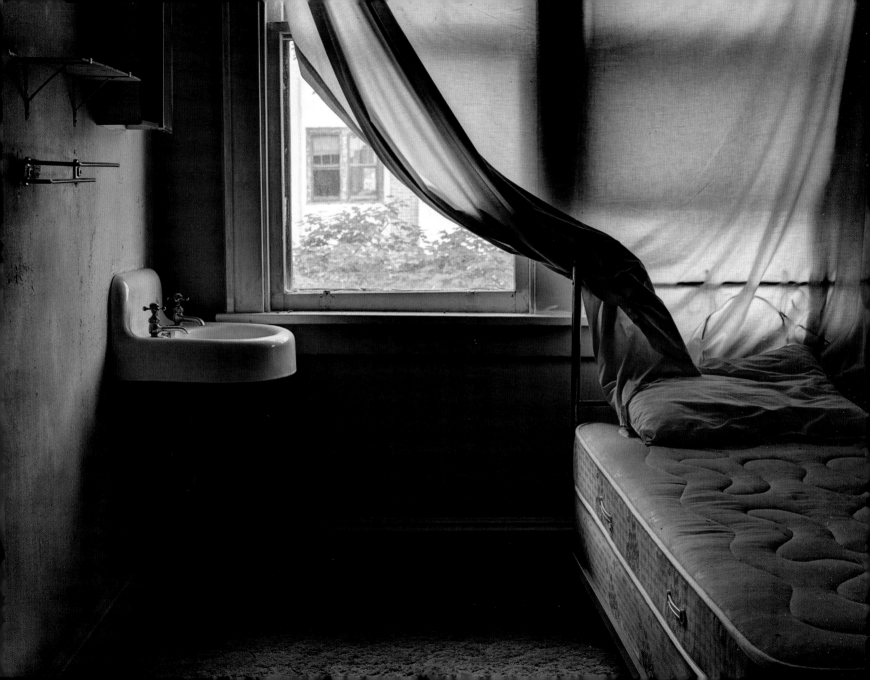

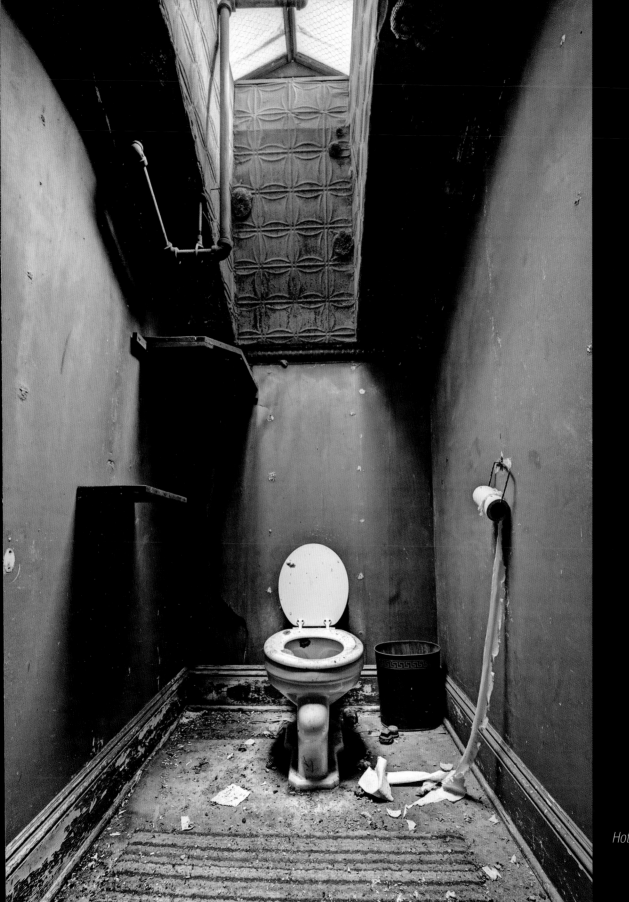

Hotel, New York

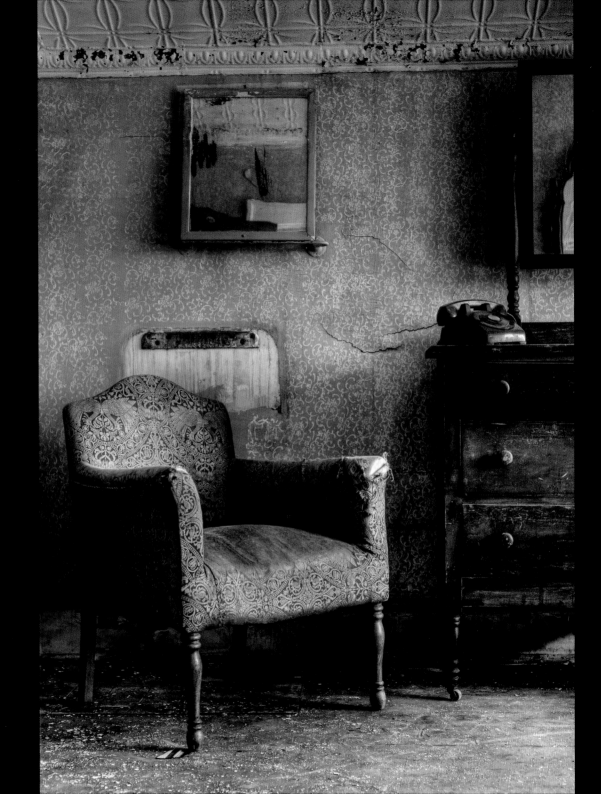

Staff quarters
Hotel, New York

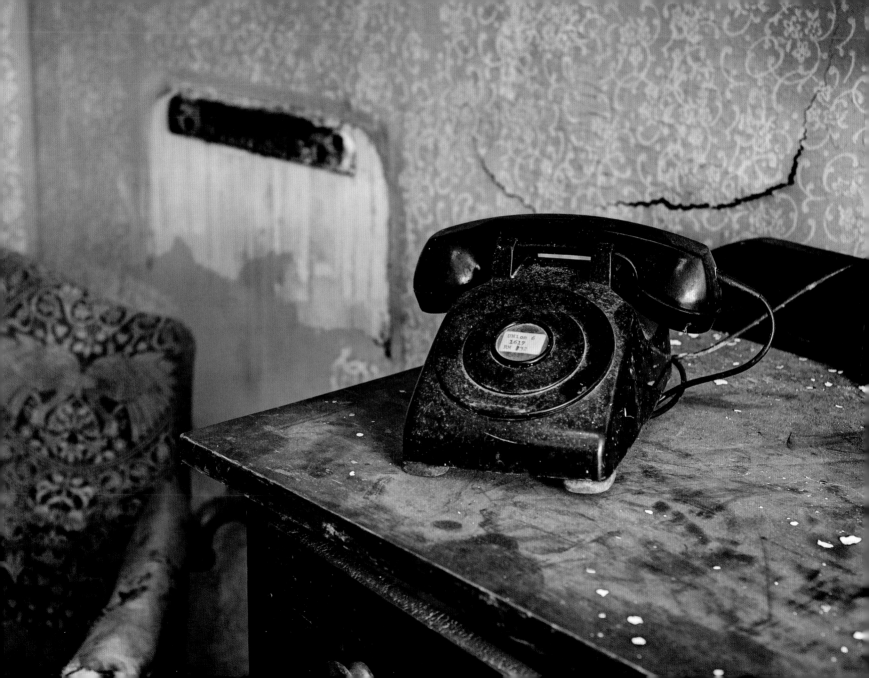

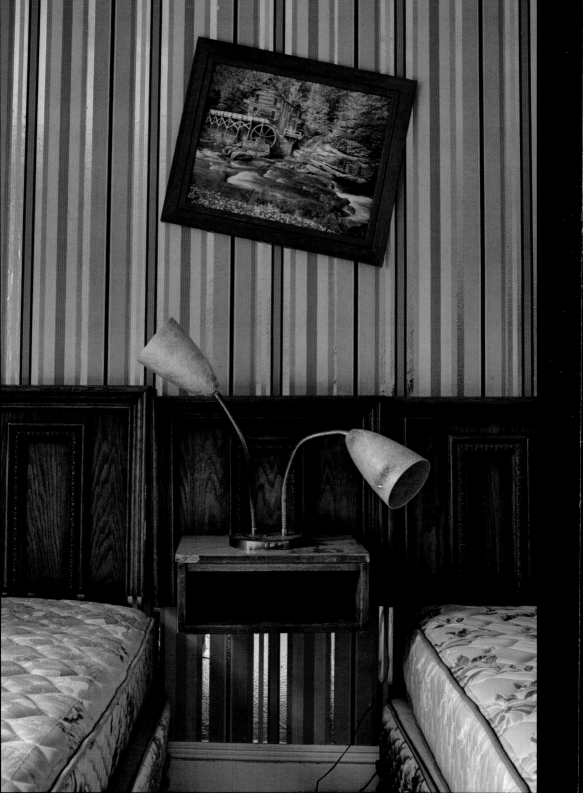

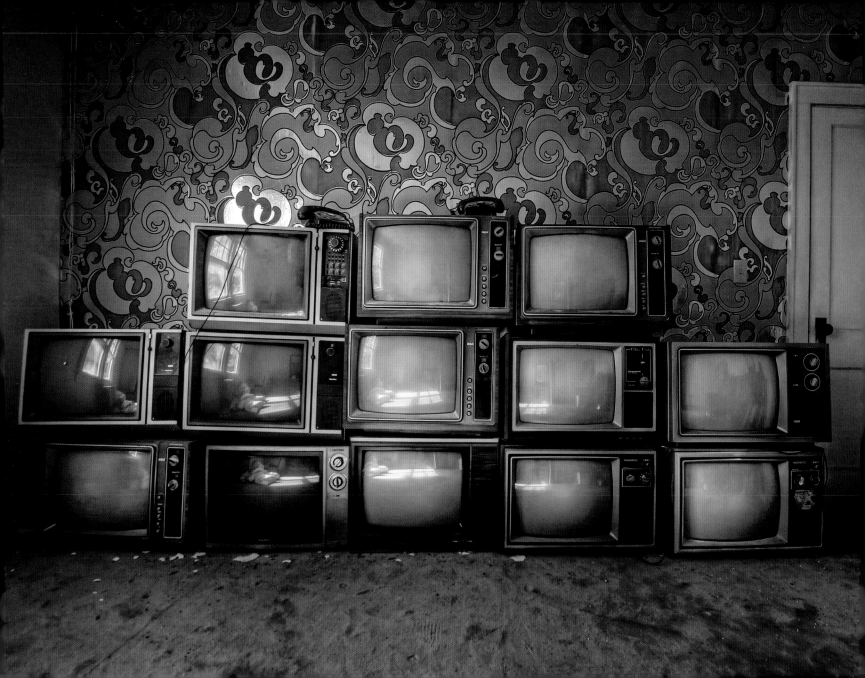

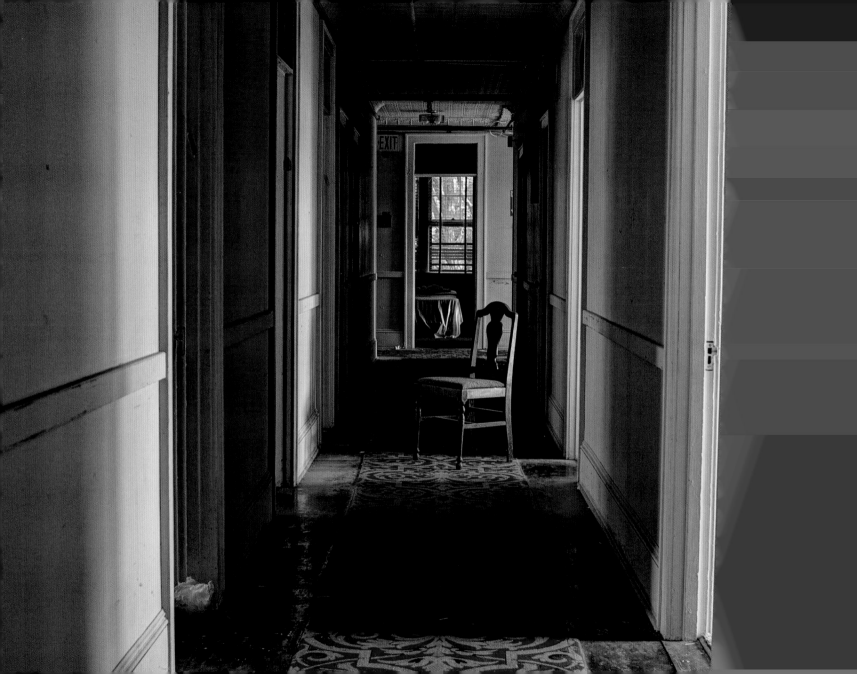

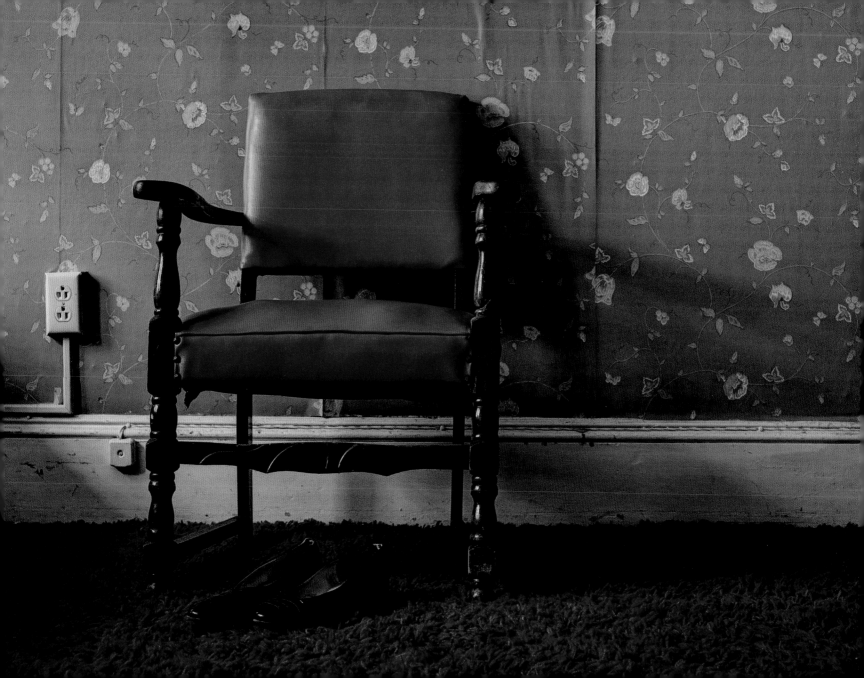

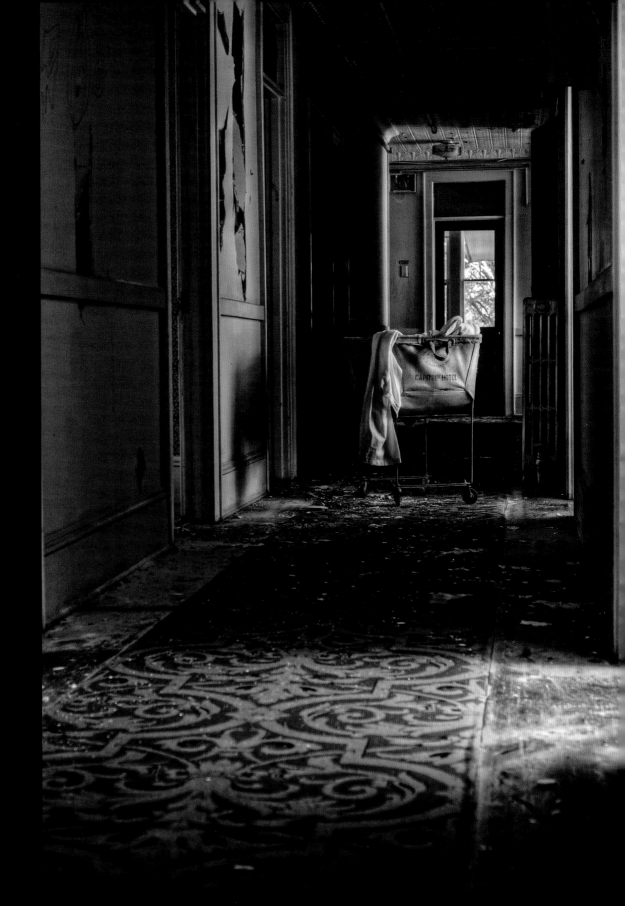

Hotel, New York

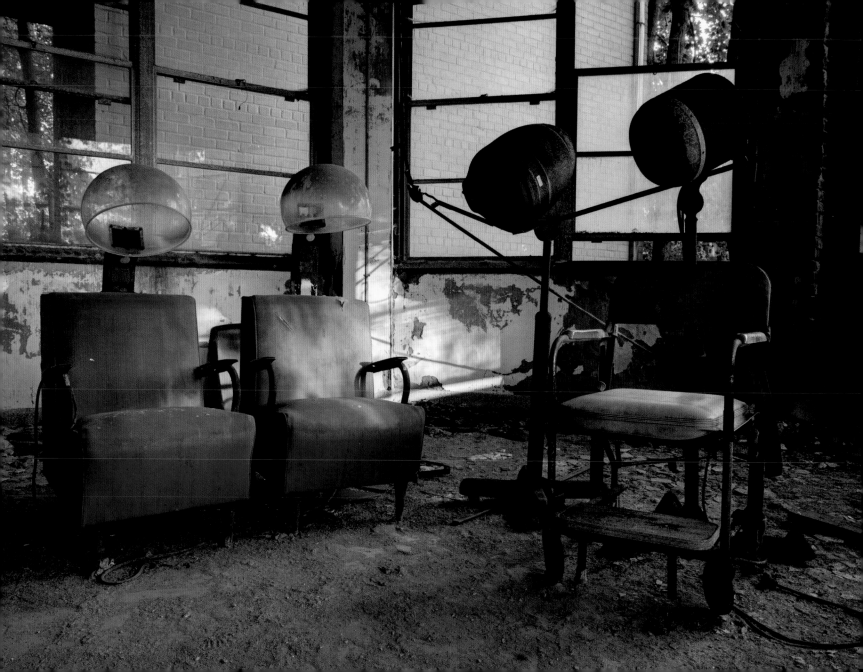

PATIENTS BATH

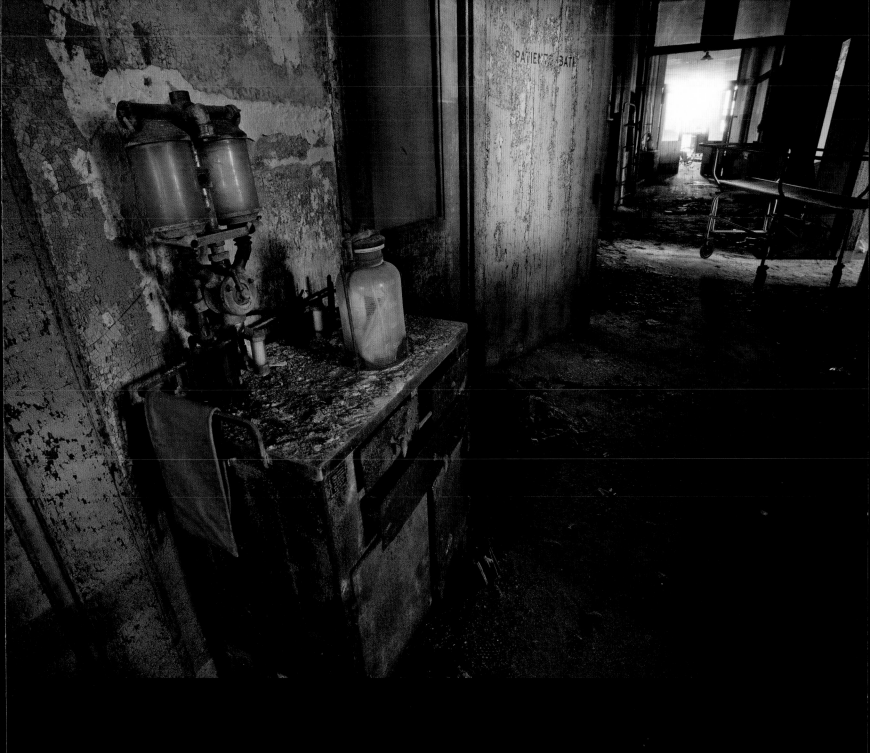

Pneumothorax machine
Sanatorium, New York

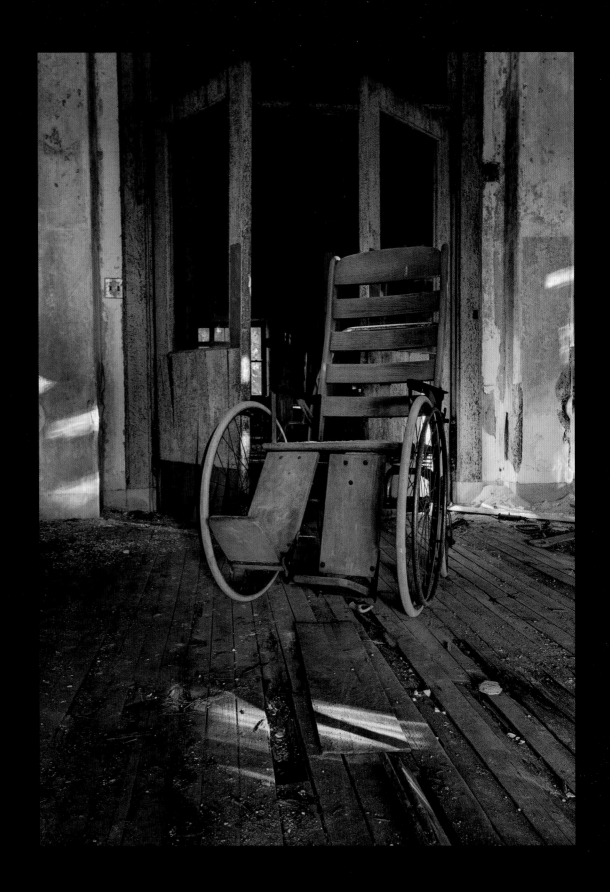

Sanatorium, New York

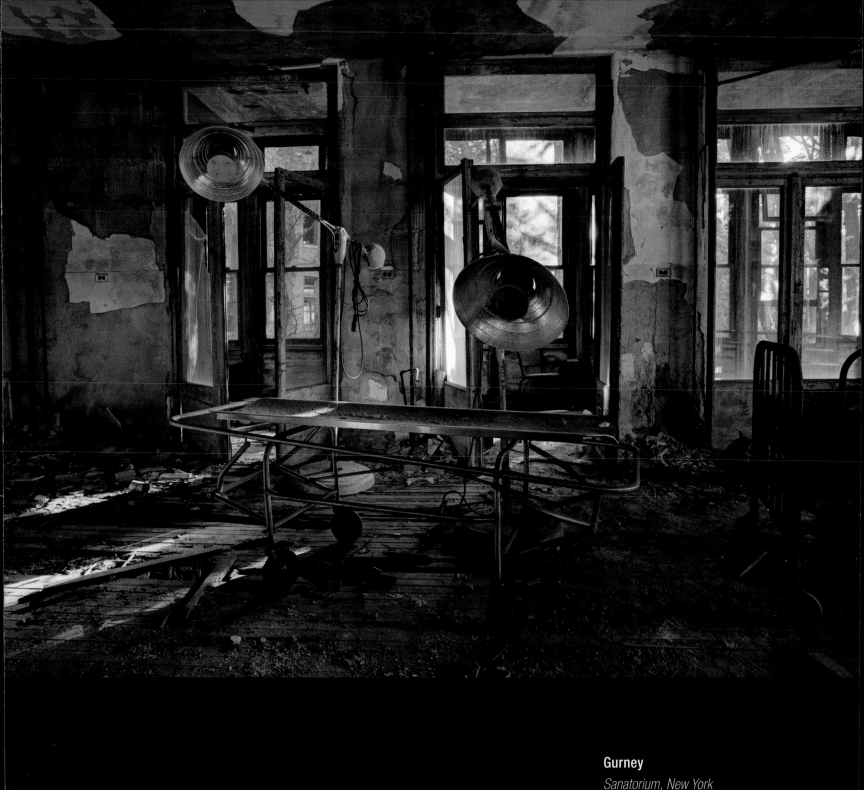

Gurney
Sanatorium, New York

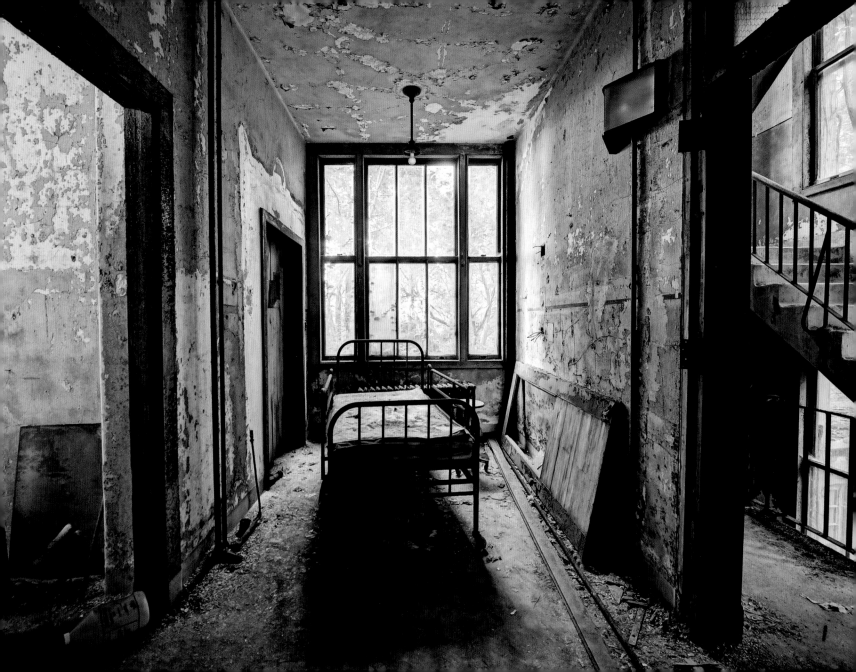

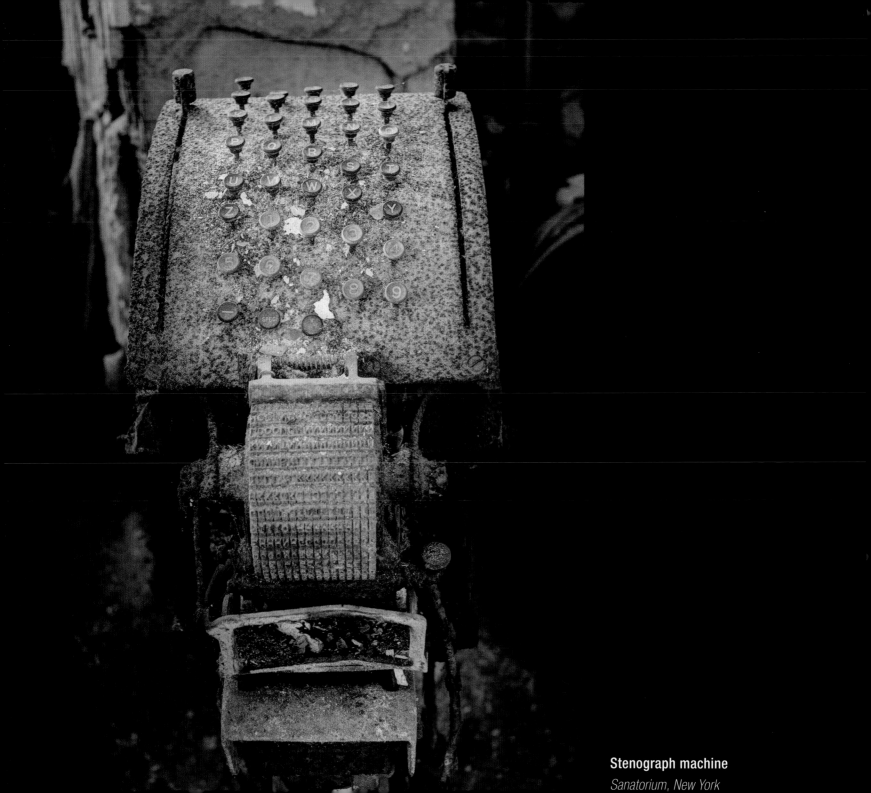

Stenograph machine

Sanatorium, New York

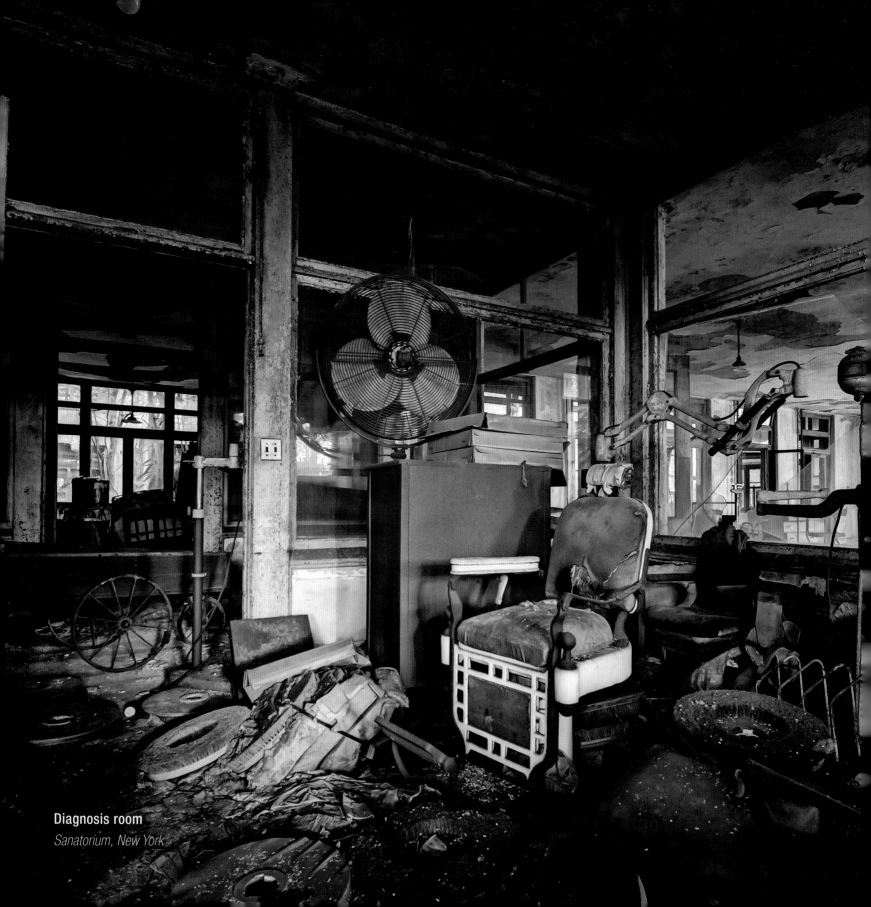

Diagnosis room
Sanatorium, New York

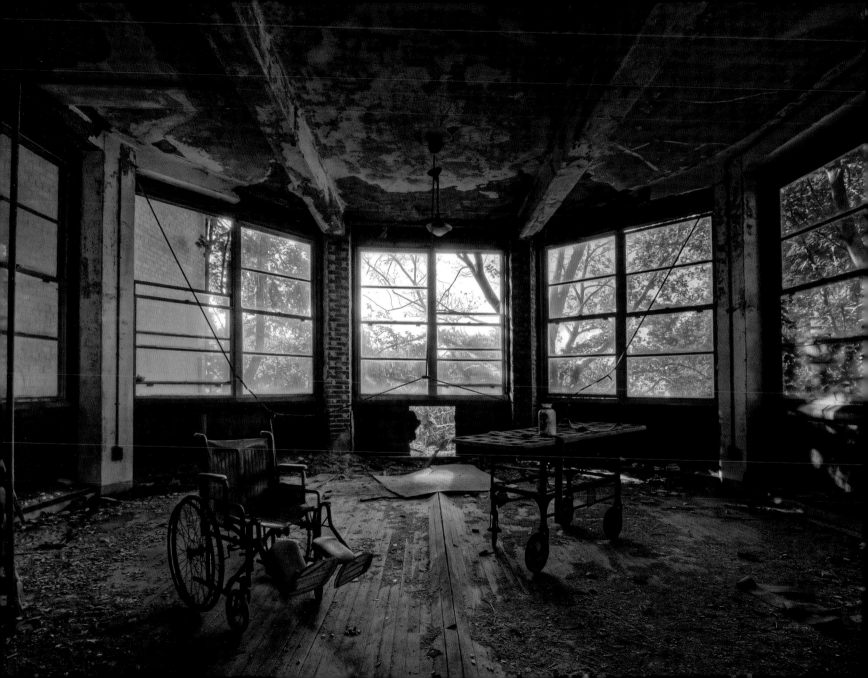

As soon as we crossed the threshold, the atmosphere changed. The heightened sensory awareness afforded to us by the thrill of gaining entry enabled us to fully appreciate the powerful aromas that encompassed us. The almost overwhelming combination of rotting wood, unchecked mould and fungal growth, crumbling plaster, and degrading paper summoned up the recent past. However, it was not just our sense of smell that was challenged and changed. The aural experience of being disconnected from the regular sounds of a bustling city, combined with the uncanny silence of abandoned places, made us feel like we had stumbled upon a secret not to be shared. The embodied experience set the imagination and memory free to ponder on forgotten memories and the small fractured stories of the people that once lived, worked and visited these spaces.

As we ingested these thoughts, the air seemed to stand still. As the seconds ticked away, the wind whistled around the outside of this decaying memorial to American elitism. What is more, we felt wrapped in the fabric of the place, part of its materiality and memory, but at the same moment adding to its continued historic existence.

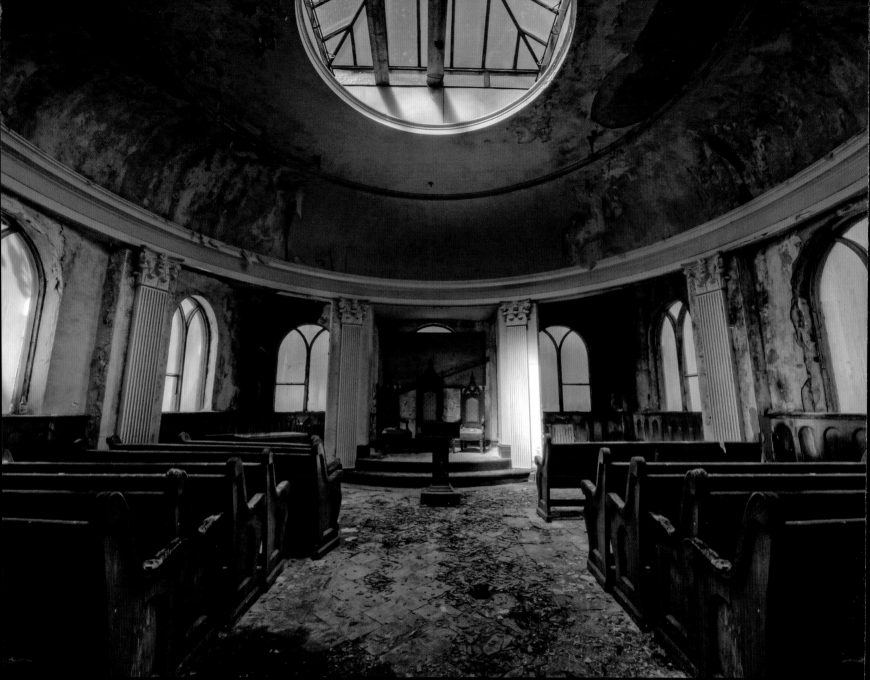

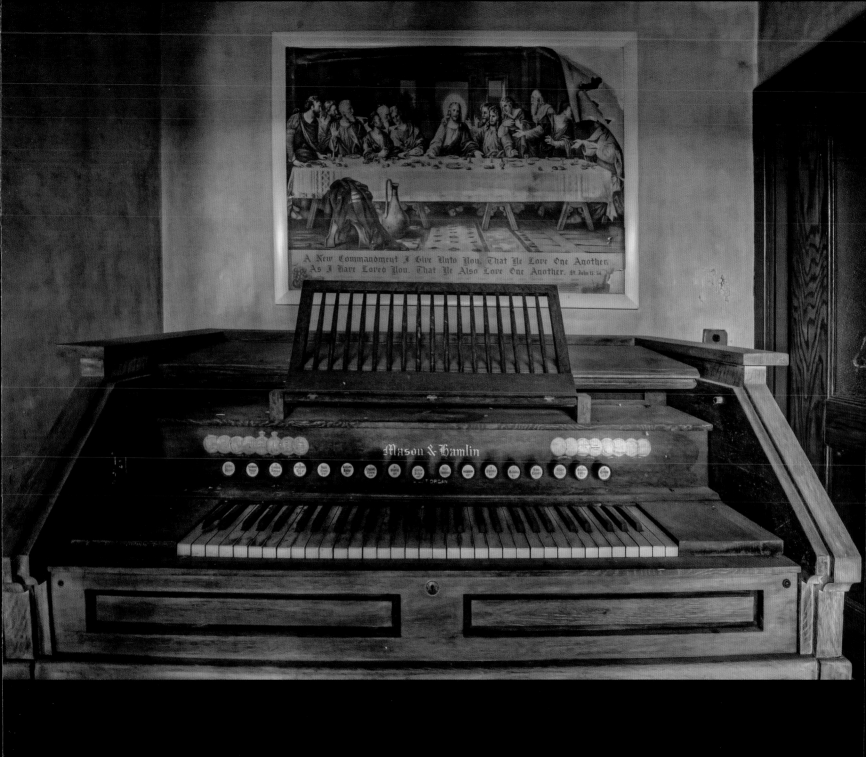

Reed organ

Masonic temple, New York

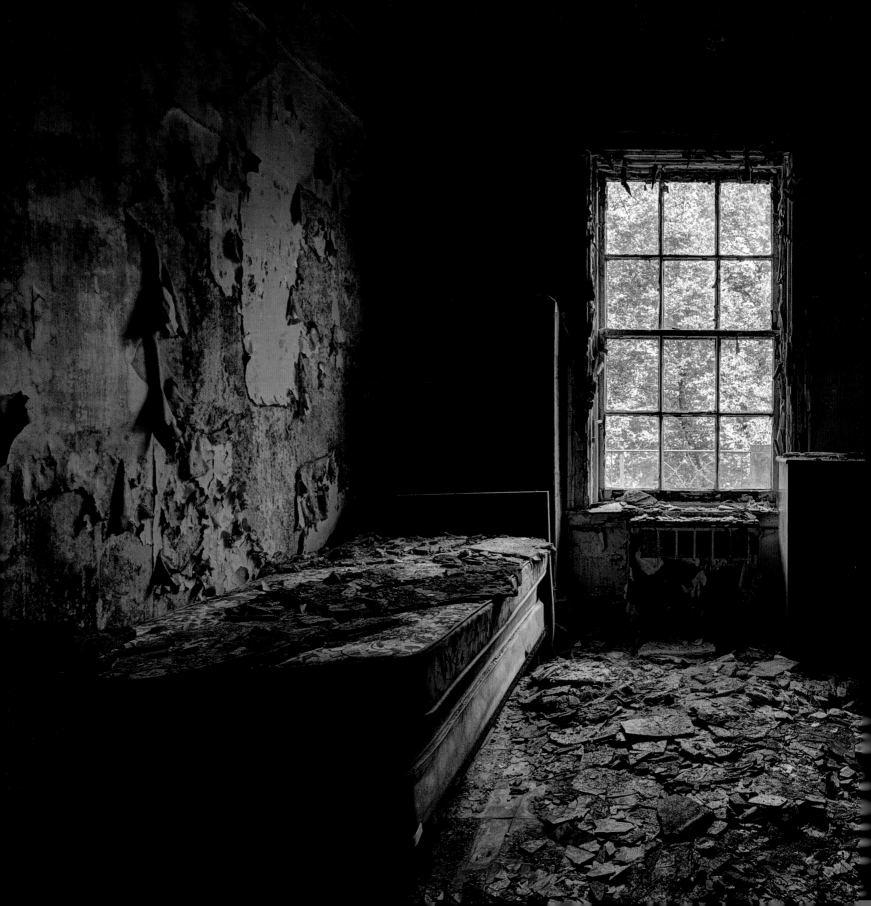

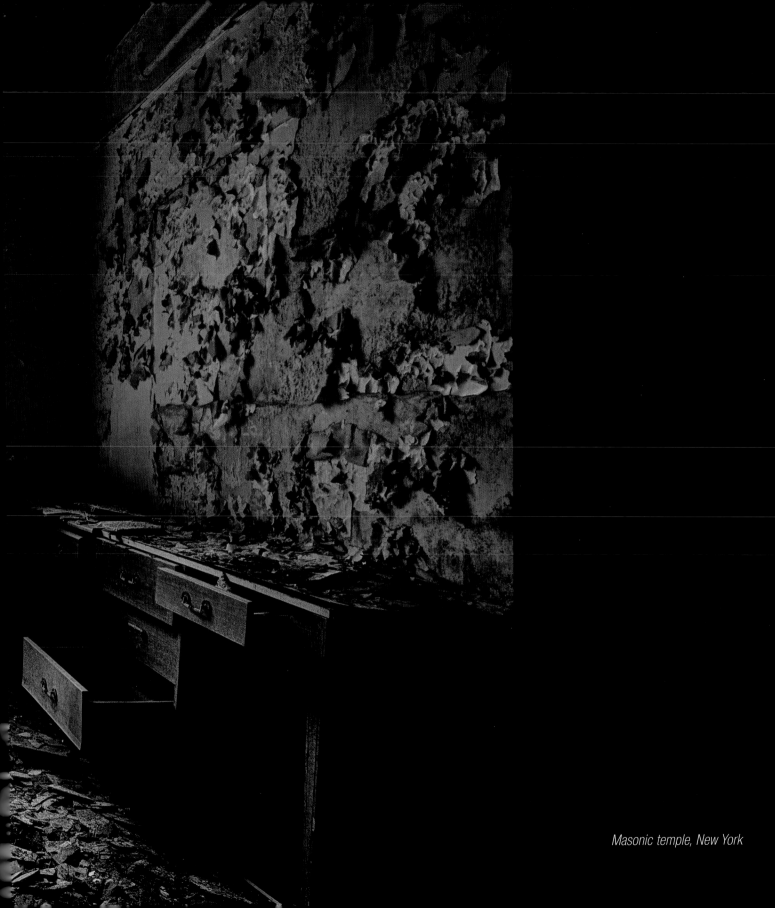

Masonic temple, New York

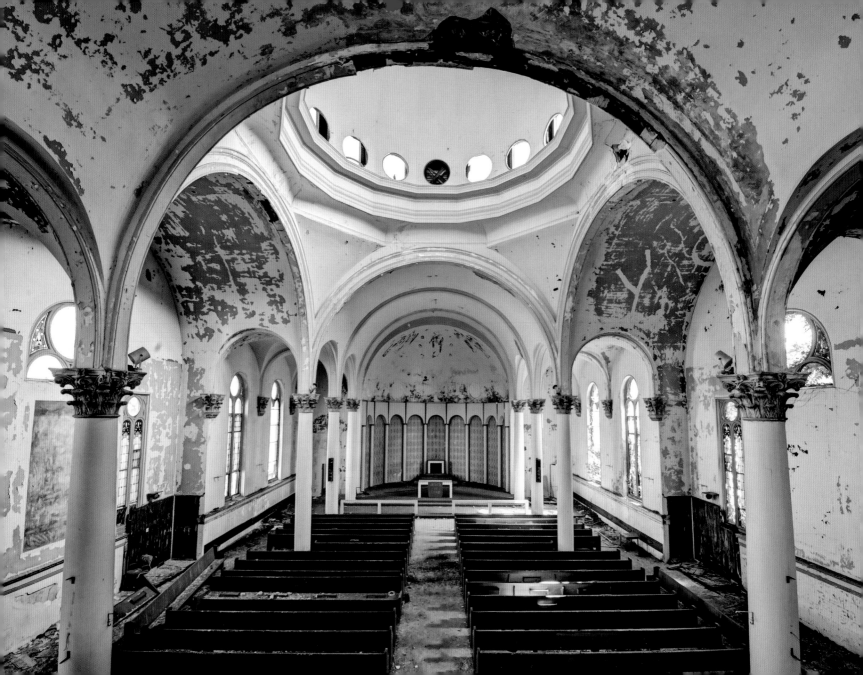

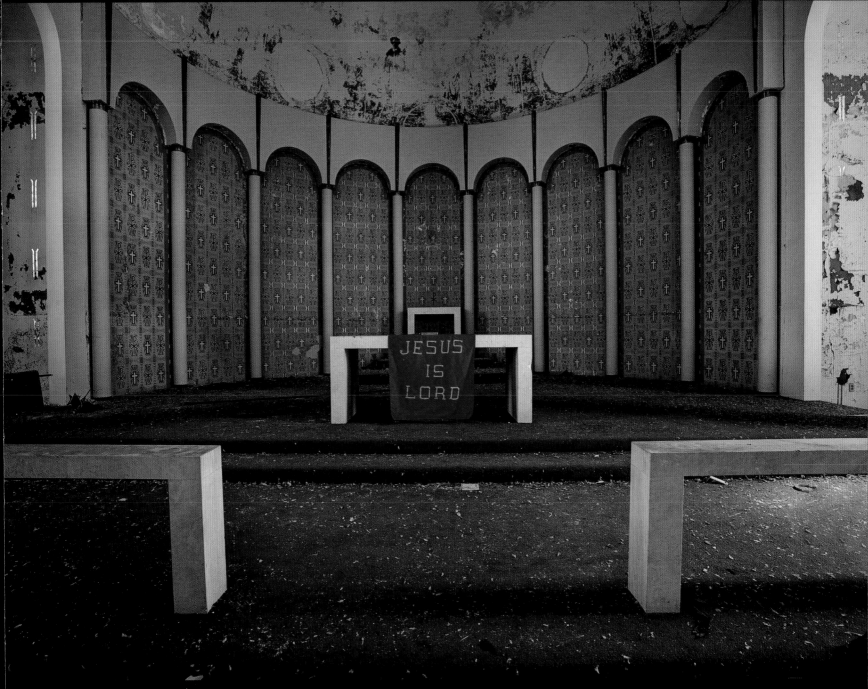

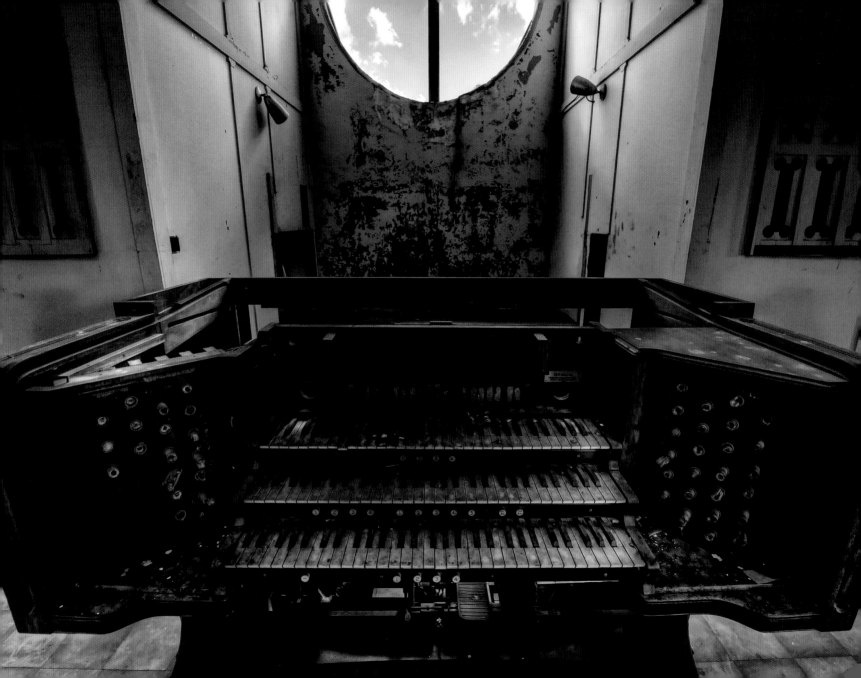

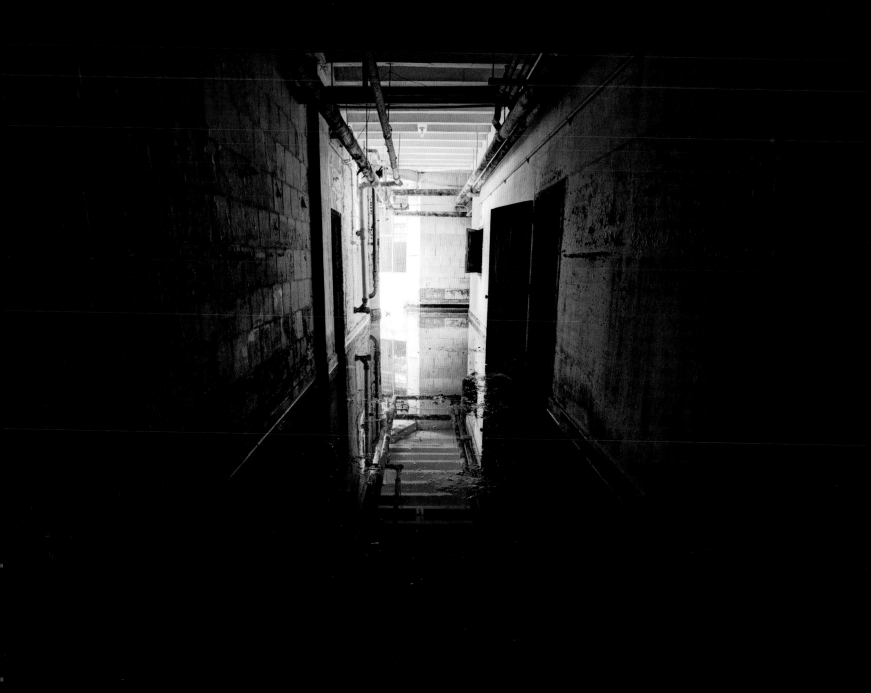

Asylum, New York

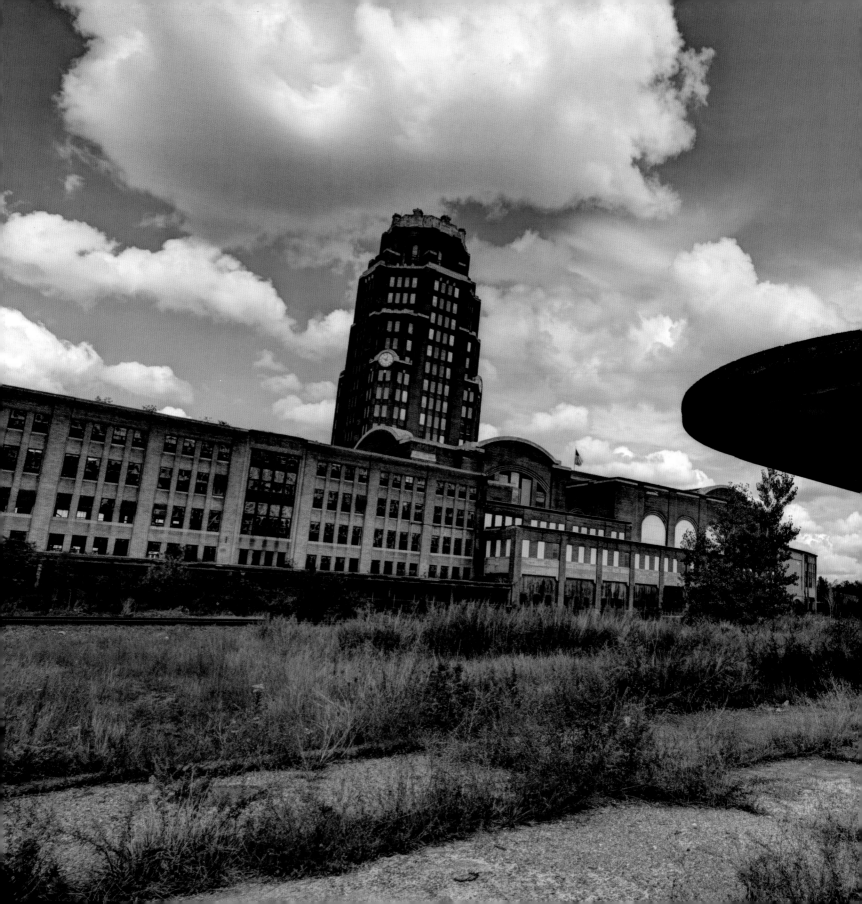

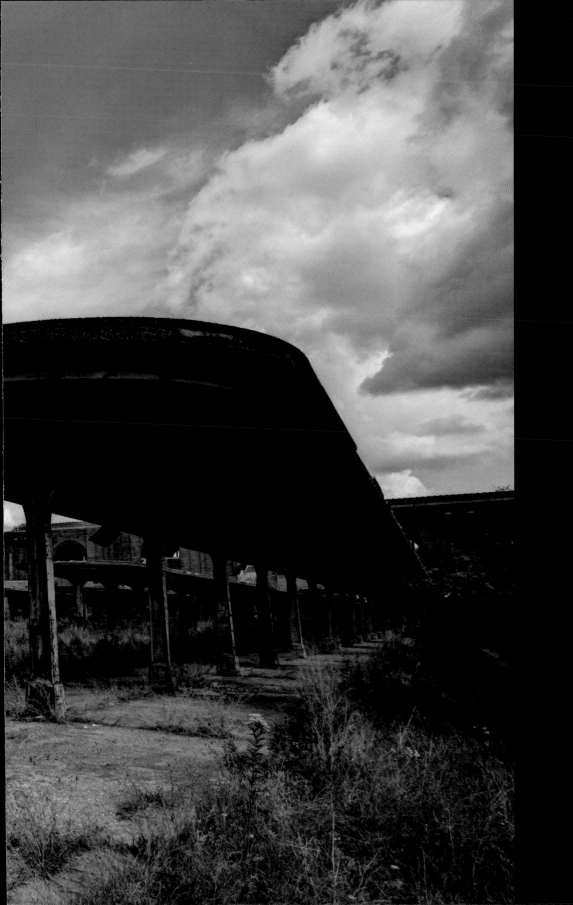

Central terminal, New York

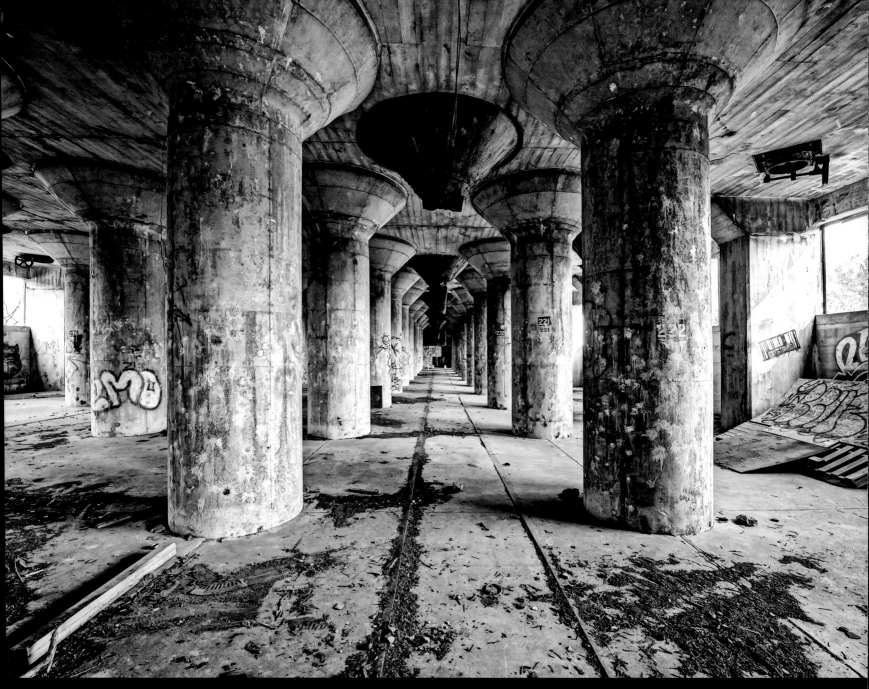

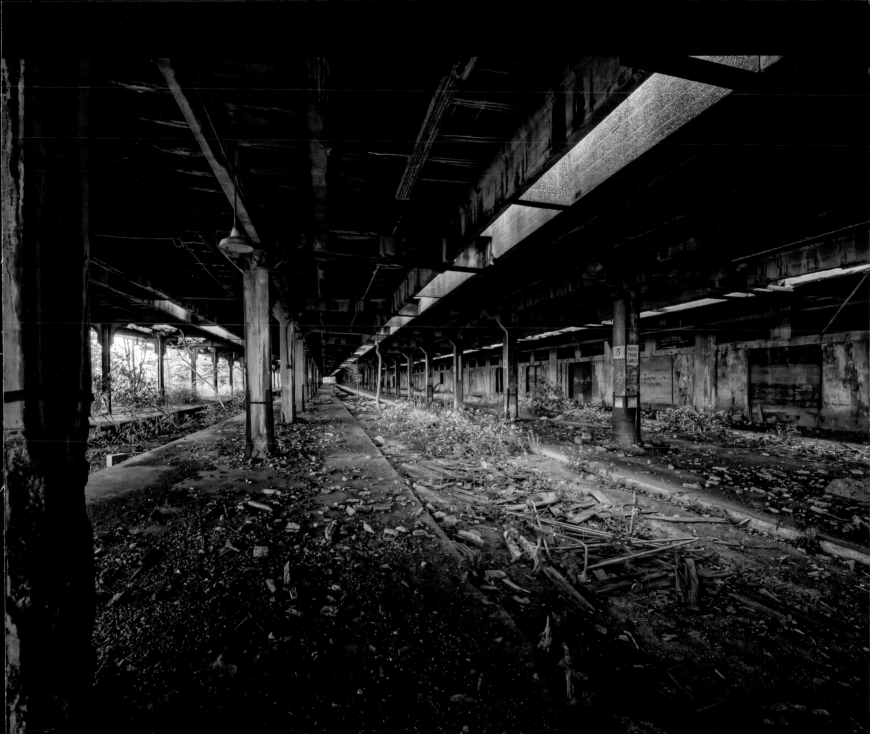

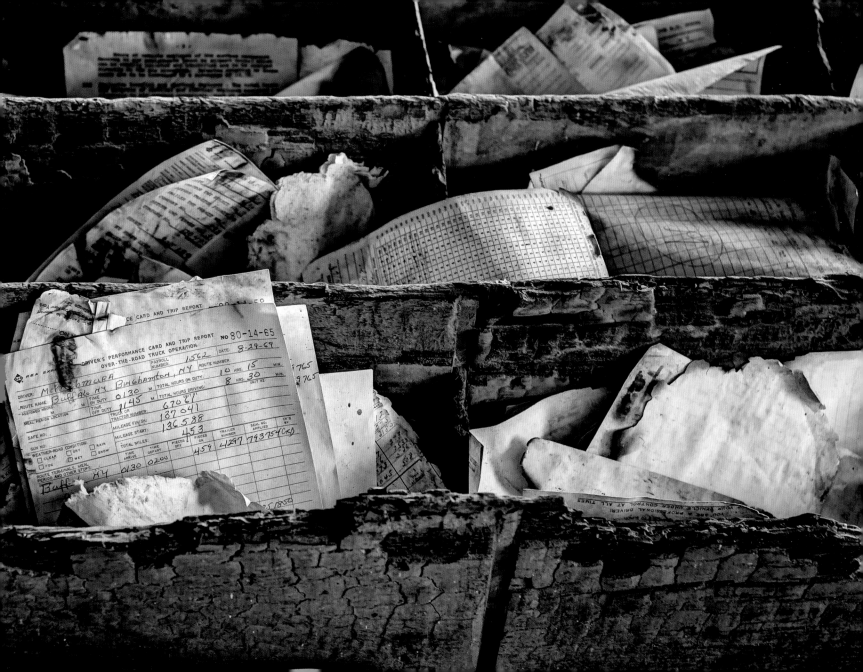

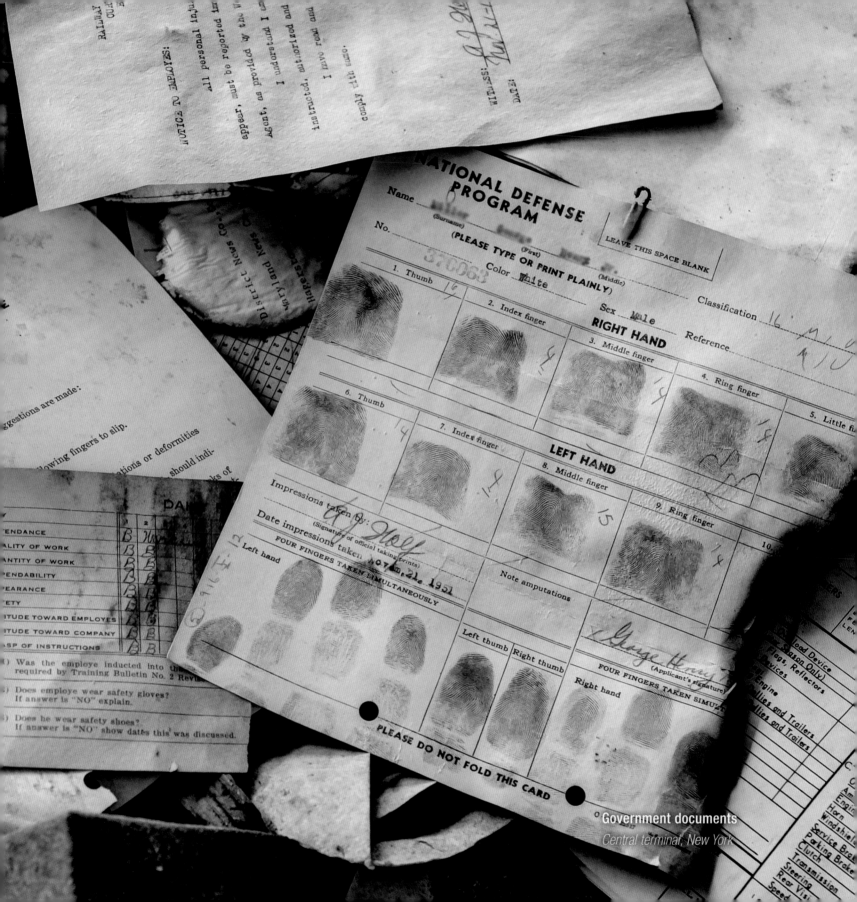

Government documents
Central terminal, New York

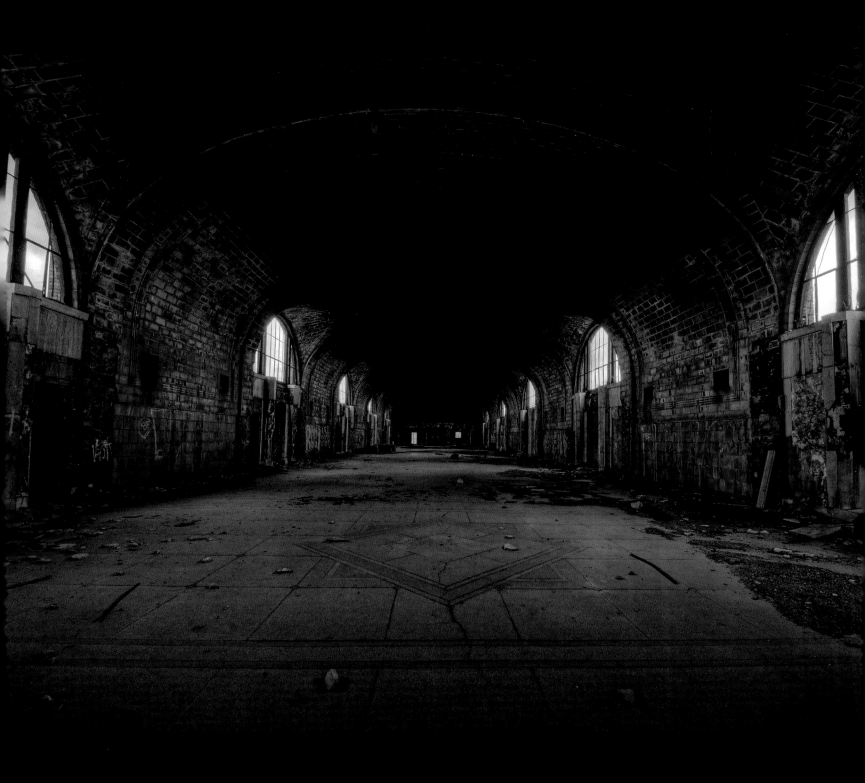

Main concourse

Central terminal, New York

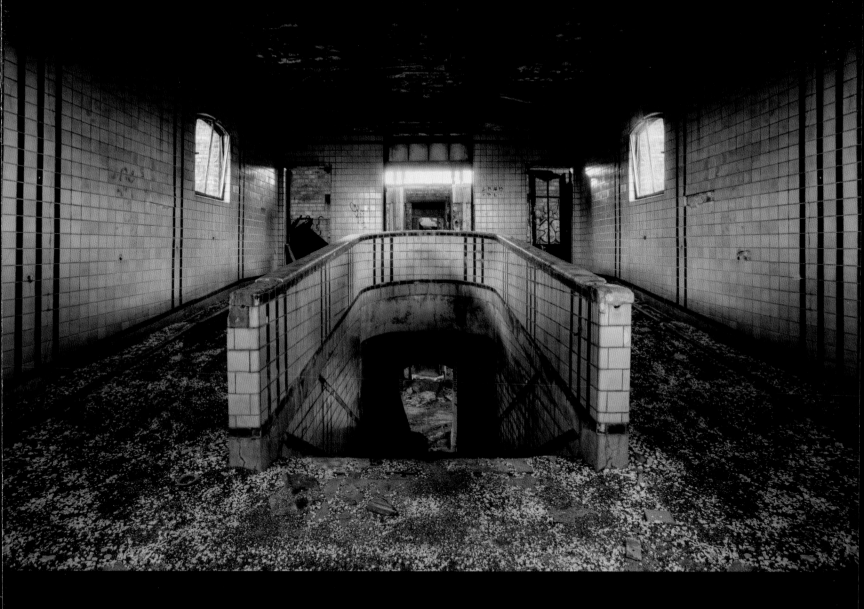

Platform entrance

Central terminal, New York

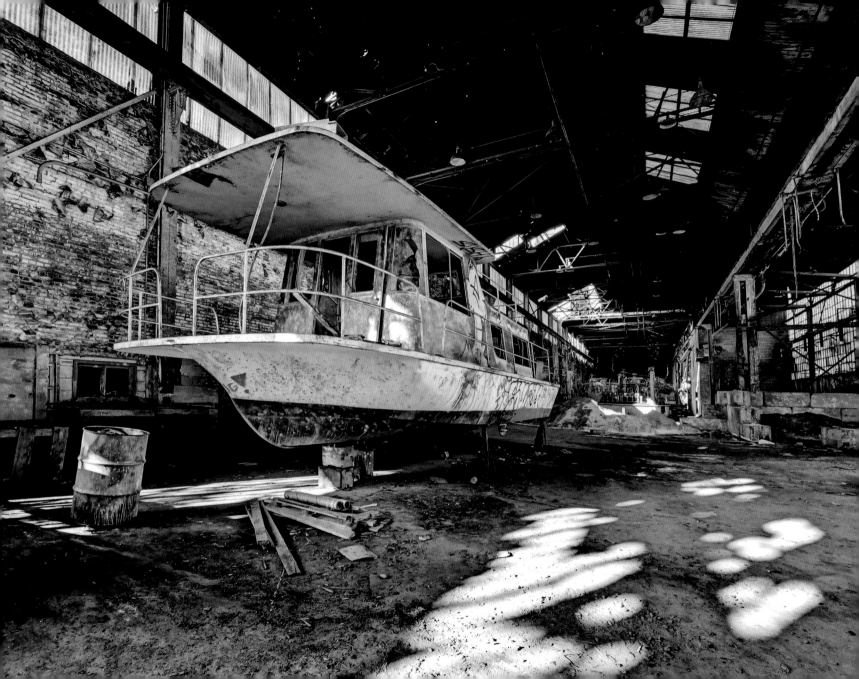

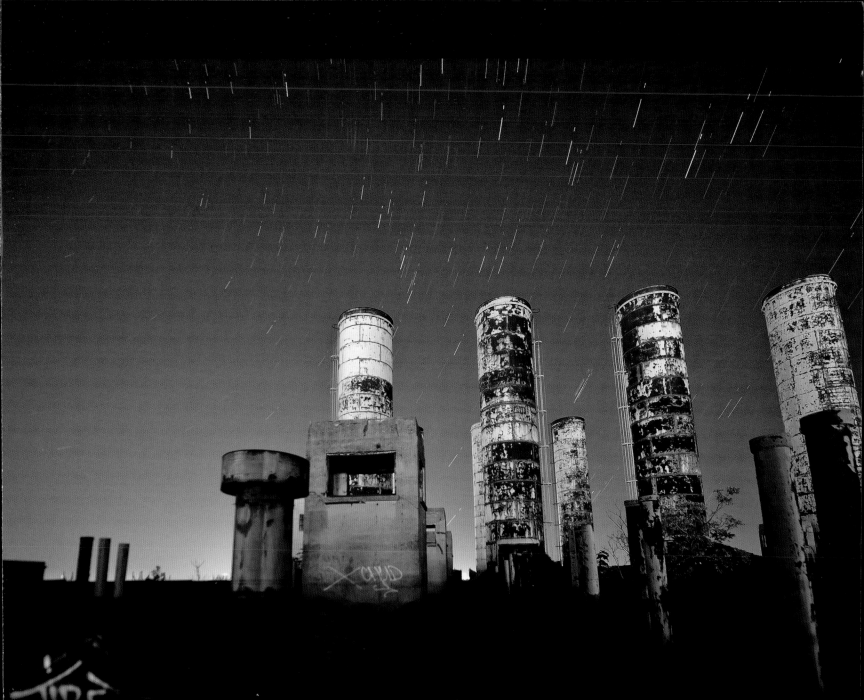

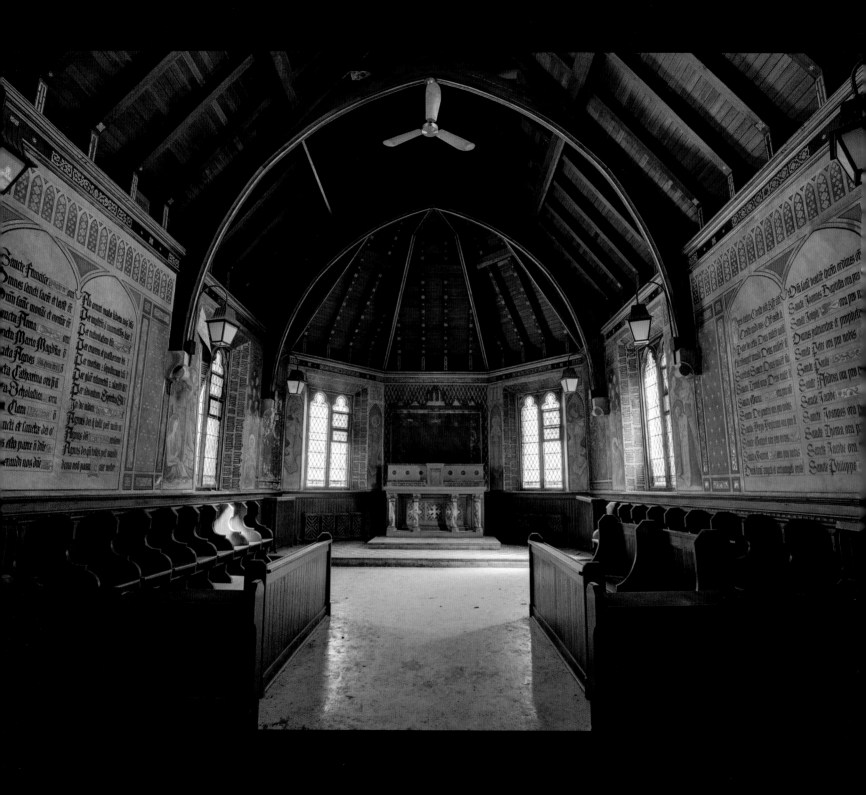

Convent, New York

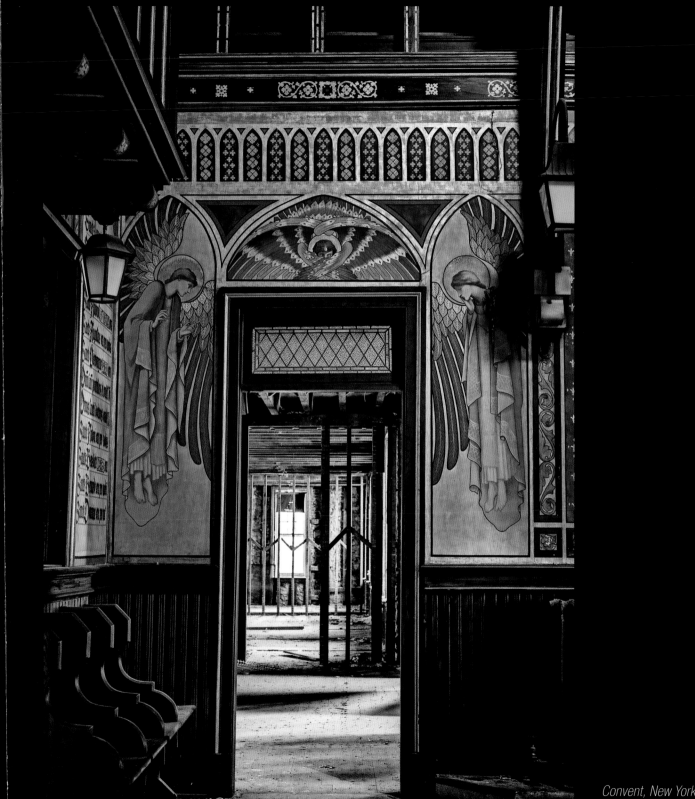

Convent, New York

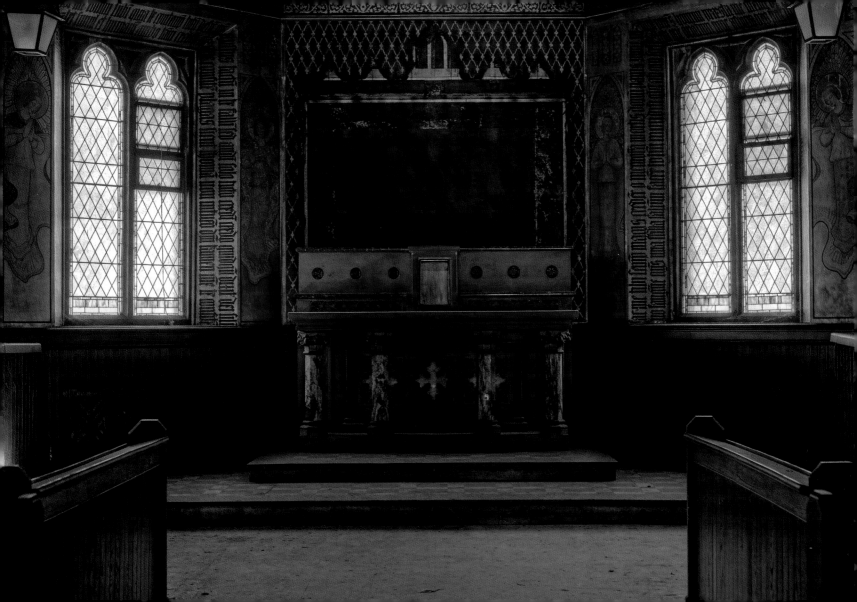

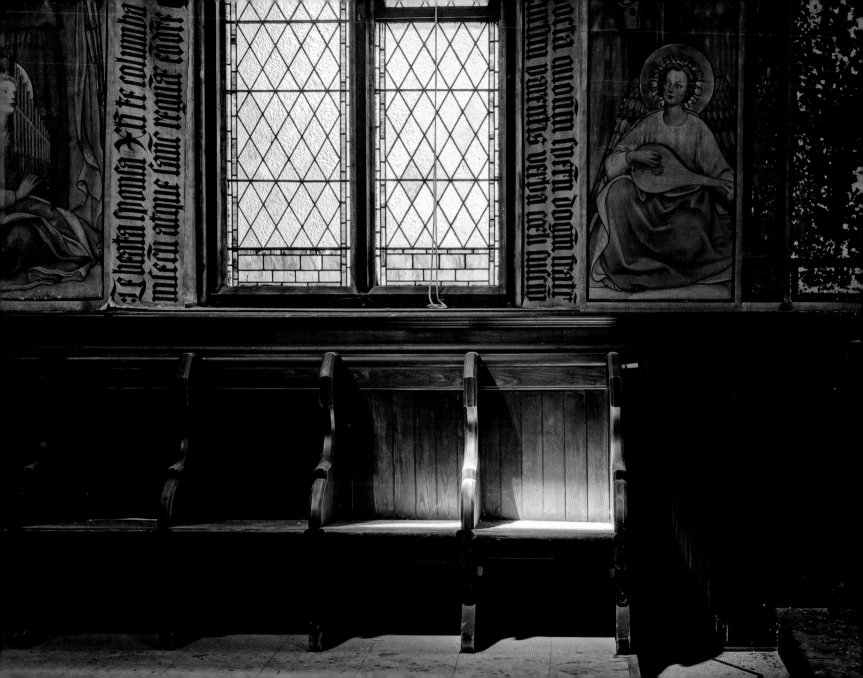

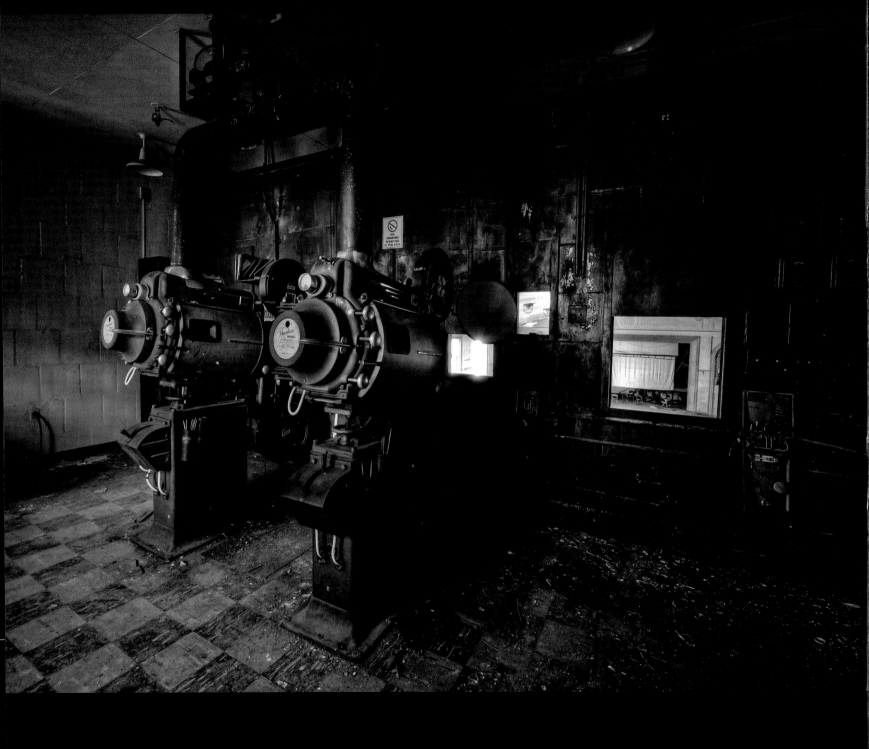

Projection room
Asylum, New York

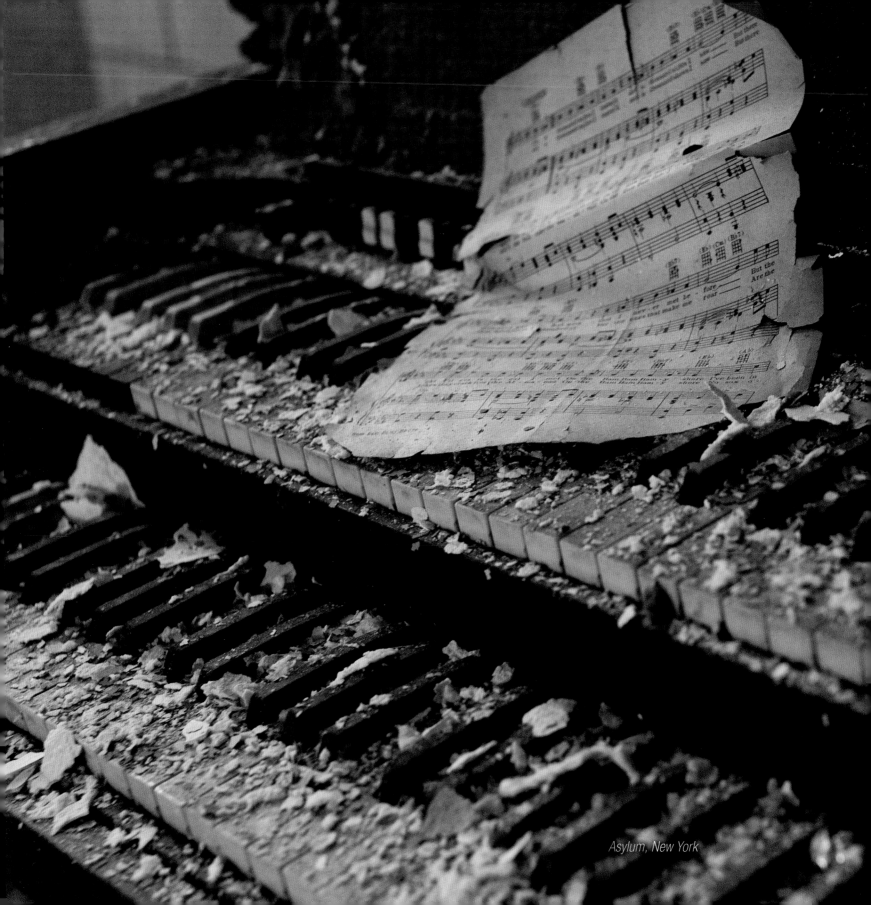

Asylum, New York

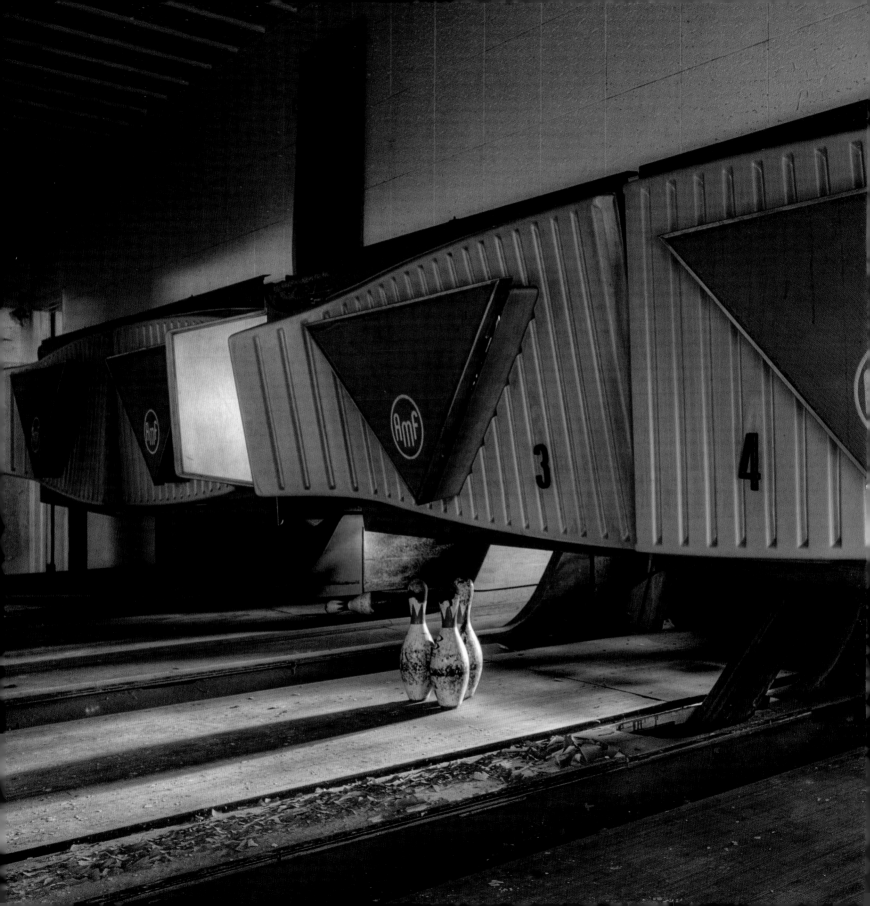

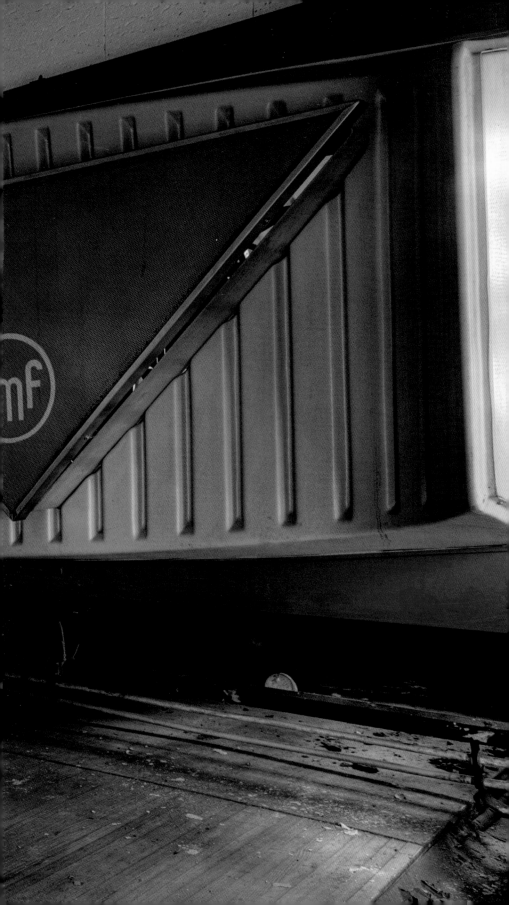

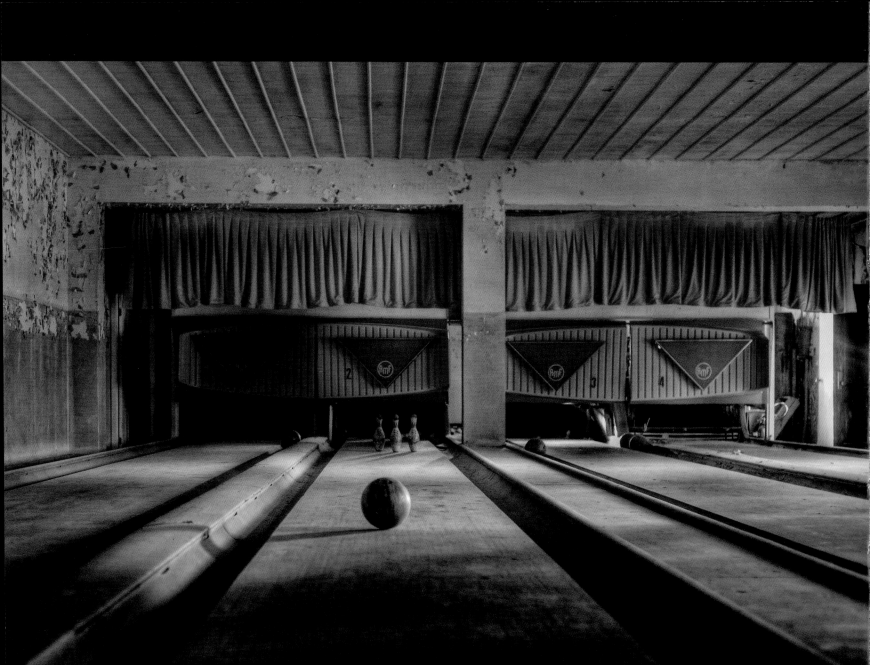

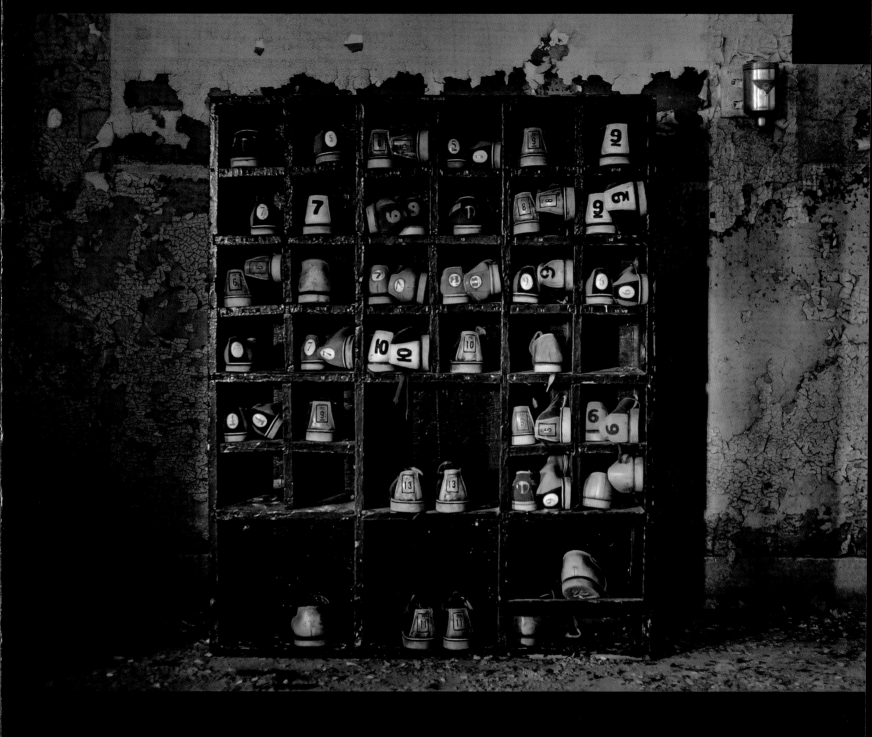

Bowling shoes

Asylum, New York

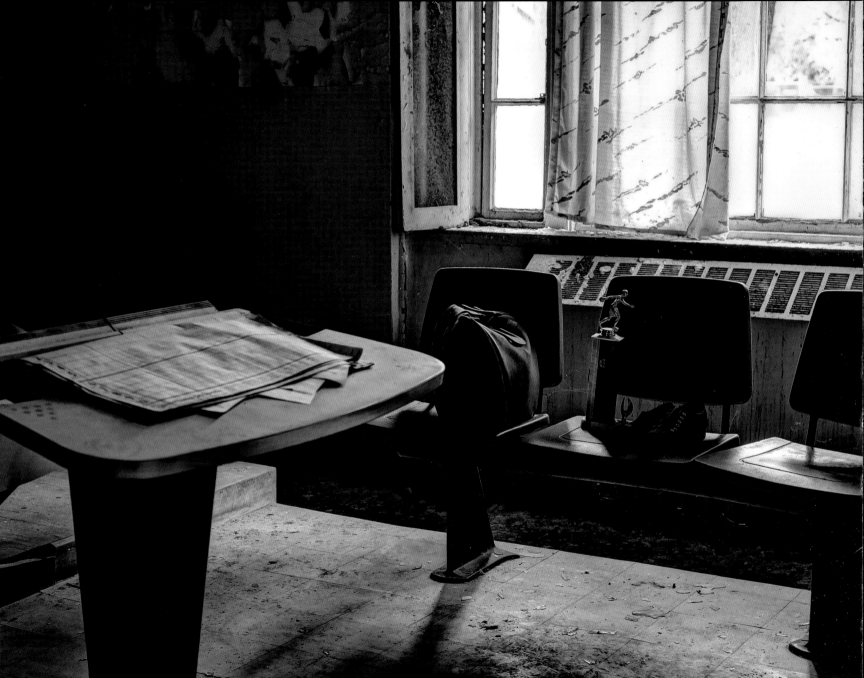

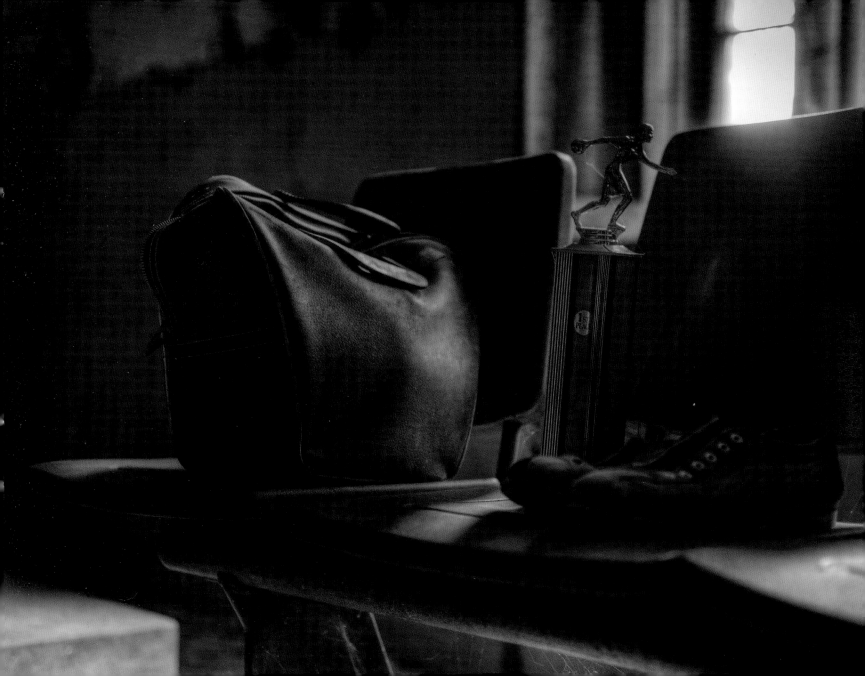

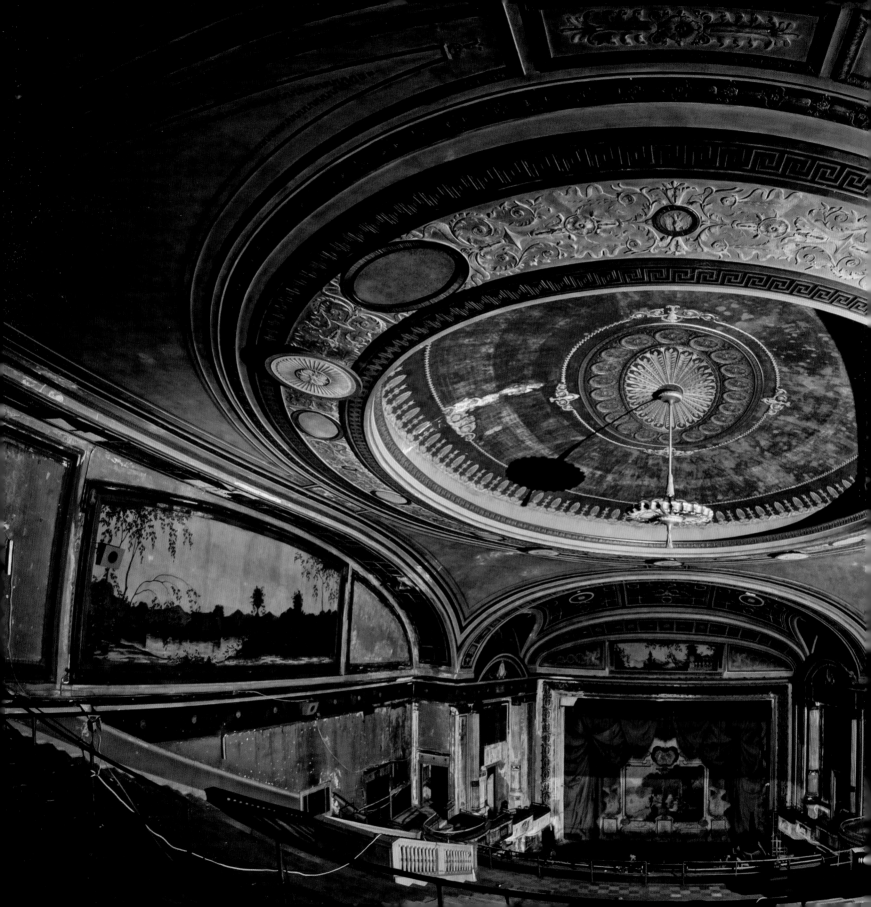

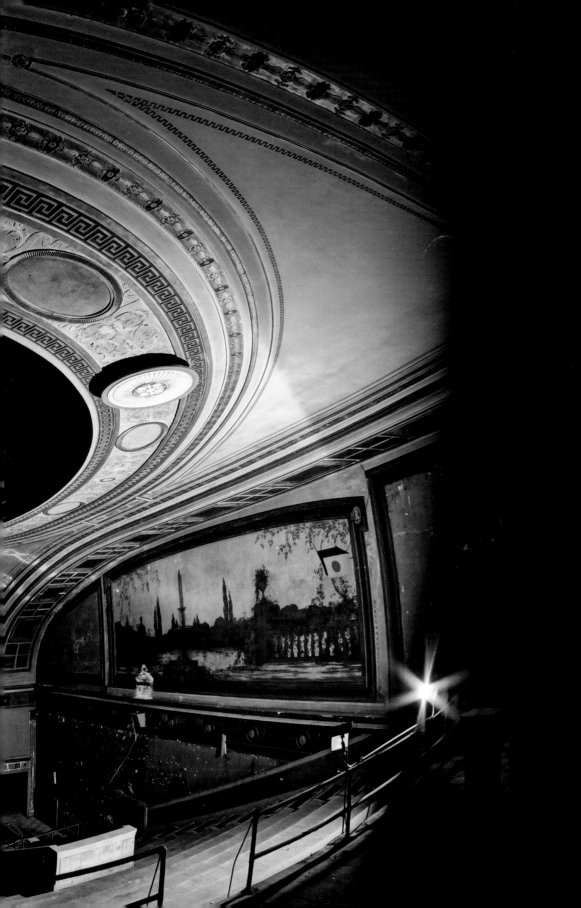

Theatre, Connecticut

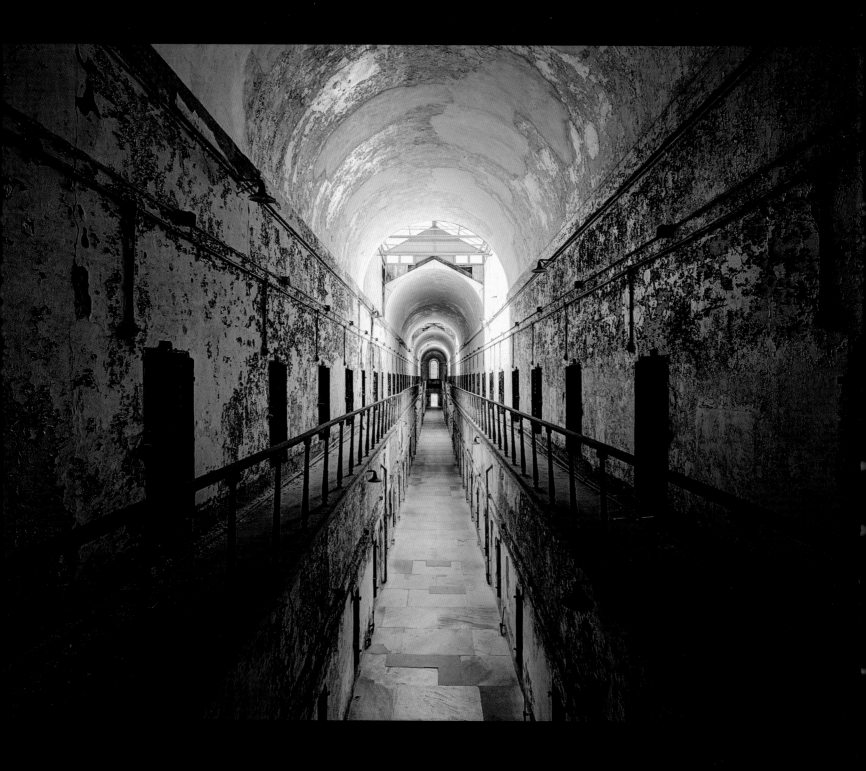

Cell block

Penitentiary, Pennsylvania

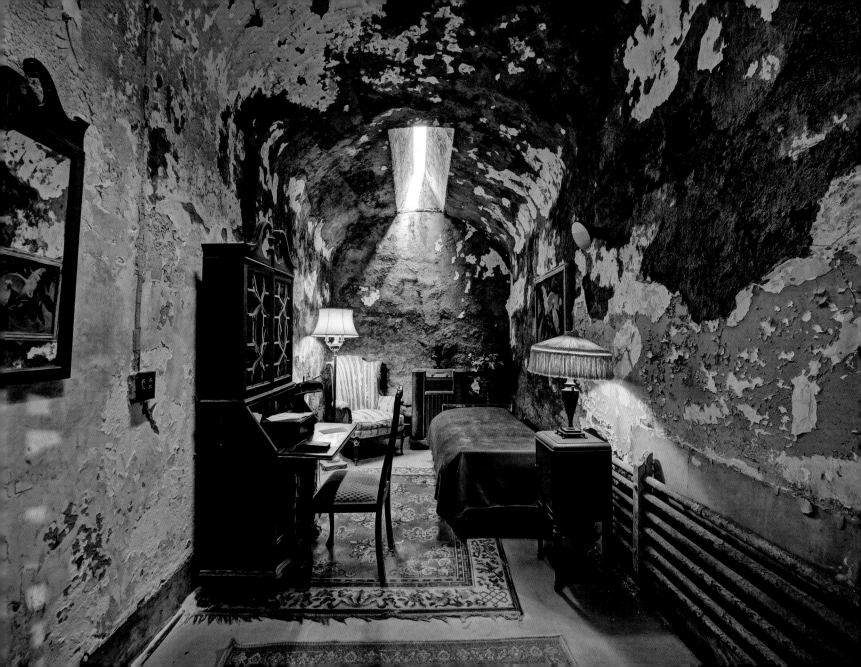

ACKNOWLEDGEMENTS

Both Daniel Barter and Daniel Marbaix would like to thank the fellow explorers across the pond, Ray, Shannon, Rich, Sexy Sean, Jeremy, Jay, Dan, Alex, Shay, Jamie, Bear, and Wombat, whose guidance helped make this book possible. We might not have been able to explore these great locations without your help and information, so we thank you.

The team at Offset; Tarkan, George, and Dr. Nadh for their help with designing the book. Also, to Drew for his red boots (and proofing). Gary at Carpet Bombing Culture, a big thank you for managing the publishing of this book. Lastly, to all our families for their unyielding support.

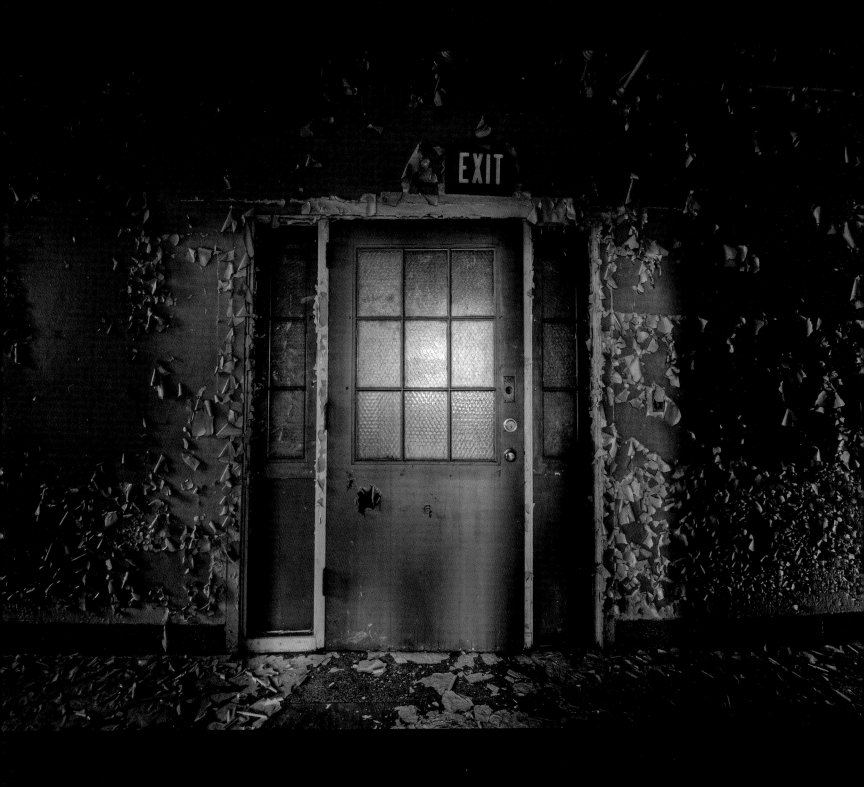

Asylum, New York